AMERICAN PHOTOGRAPHS
1900/2000

JAMES DANZIGER

ASSOULINE

[PORT

n. from the Itali

[sheet-holder

prints by an art

work in the for

was originall

FOLIO]

an "portafoglio"
(1722). Set of
st showing his
mat in which it
y printed.

INTRODUCTION

James Danziger

The first two installments of the original gallery exhibition The American Century were co-curated with my colleague Stephen Daiter of the Daiter Gallery in Chicago. His participation was vital, and his knowledge, friendship, and markedly different aesthetic from mine gave contrast, ballast, and depth to our collaboration.

American photography from the years 1900 to 2000 is arguably the most fertile period in the rich history of the medium. It is possible, indeed, to argue that it represents the most fertile period in the entire history of art! Before throwing this idea aside, consider for a moment the steps that were taken to get from a quasi-painterly aesthetic to a photographic vision that encompassed documentary photography, modernism, post-modernism, and conceptualism. Furthermore, examine the richness and depth by which American photographers constantly reinvented the classical tradition of straight-forward observation. At its most simplistic, this line goes from Stieglitz to Weston to Evans to Adams to Callahan to Penn to Frank to Avedon to Meyerowitz to Friedlander to Eggleston to Leibovitz to Sugimoto and Fuss. Consider that photographic images have become the dominant form of non-verbal communication all over the world and that, for better or worse, American iconography is the dominant global iconography. Finally, consider that twentieth century American photography's greatest victory was that, by the last decade of the century, it had a greater influence on the so-called "fine art" world than the reverse. That is the argument.

This book is derived from a series of exhibitions put together over three years at the Danziger Gallery in New York. Originally entitled *The American Century* when the series began in 1997, the title was changed for this book when the flow of subsequent *American Century* exhibitions, books, television programs, etc. became overwhelming. Presented in three installments that divided the century (1900-1935; 1936-1967; and 1968-1999), the exhibitions were an exploration, a celebration, and a discovery of two hundred and fifty singular images. Surprisingly, there is no significant volume that

focuses exclusively on twentieth-century American photography, and so catalogues were published for the first two parts with the intention of assembling them into one volume when the project was completed. I am grateful to Prosper Assouline for his vision in making this idea a reality. Following the timeline of the original exhibitions, I will discuss the work in three chronological sections.

From 1900 to 1935 the theoretical arc of photography in America traveled from the expressive sensibility of the photo-secession to the bold new outlook of modernism—from the Freudian passions of Alfred Stieglitz to the poetic objectivism of Walker Evans. The documentary and exploratory tradition of the nineteenth century was acknowledged, but added to this terrain were intellectual and personal dimensions. Later, and throughout the century, an explosive infusion of energy from the commercial and industrial world served to spice up the pot. (In fact there is a fruitful history of its own of an enriching dialogue between straight photographers alternating personal and commercial work.) If photography from the first third of *The American Century* (to gratefully borrow Henry Luce's spirited phrase) lacks the singular outburst of the European New Vision photography with its connections to the period's painting and sculpture, it more than makes up for this with its powerful and continuous stream of creativity and vision. Furthermore, in American photography, the desire and intellectual capacity to search for new modes of seeing are considered in particularly modern ways inherent to the medium. Culturally and artistically, there is probably no single area in which America has so gone on to dominate the century as with photography.

Led by Alfred Stieglitz, whose work not only as a photographer, but as a mentor, promoter, and experimenter kicked the whole medium into life, photography woke up. Stieglitz was born in Hoboken, New Jersey in 1864, studied in Germany, and moved back to America at the start of the new century. He founded the publication, *Camera Work,* introducing the work of photographers as diverse as Baron De Meyer, Clarence White, Gertrude Kasebier, and Edward Steichen. After fourteen years of publication, Stieglitz ended with a seminal issue featuring the work of Paul Strand—a gritty, uncompromising look at modern urban life. Stieglitz then went on to produce two major new bodies of his own work. The first, which he called *Equivalents,* were cloud studies on which he based a theory of looking at photographs that blended observation,

abstraction, and emotional or subconscious interpretation. This theory dominated photography for the next half-century. Then he went on to make a series of portraits of his wife, Georgia O'Keeffe, that still stand as probably the most complete and satisfying photographic representation of any one person.

At the same time, Stieglitz's friend Edward Steichen had moved from his pictorial/-modernist roots to become the top commercial photographer of his era. His fashion photographs for *Vogue* and celebrity portraits for *Vanity Fair* brought a whole new level of glamour to the medium, and this glamour could now be seen as the most influential aspect of photography as it related to the current visual language of our times.

Both in this book and the exhibitions, I attempted to select fresher and less-known masterworks along with the best-known pieces. Each informs the other. A sense of the landscape can only be put in perspective when the smaller peaks are taken into account along the pinnacles. There is also a tendency to stop really seeing pictures when the image has been too frequently exposed. (The fate of Ansel Adams' *Moonrise over Hernandez,* surely the greatest photograph taken in America in the 1940's, but now perceived by nearly all photographic cognoscenti as a trite piece of calendar art, is a spectacular example of this.) Thus a change of context serves to refresh and reintroduce the qualities of a masterpiece that have been diminished through repeated viewing.

The lesser-known images may have failed to reach iconographic status for a number of reasons—first of all through simple neglect, but also because an artists may have had only a short burst creative ferment which led to his best work, or been out of step with the times, or perhaps not cared about recognition. (We shall see a shining example of this later in the work of O. Winston Link, which was undiscovered for close to three decades.) Yes surely the validity of any individual image resides as much in the image itself as in the reputation of the artist.

A masterpiece is a confluence of factors—time, intent, event, content, print quality, image quality, idea, theme, text, subtext, innovation, composition, light, tone, and countless other factors—but each engaged so delicately that these factors—but each engaged so delicately that these factors are subsumed by the overall impact of the work. Thus along with an Alfred Stieglitz *Equivalents,* Baron Adolph De Meyer's Josephine Baker, and Edward Weston's Dune, we find Margarethe Mather's *Puppet*, Ralph

Steiner's *Madison Square Garden Tower,* Kurt Baasch's *Railroad Signal*. The dialogue between the well and lesser-known is the backdrop of history. In addition to this, each object brings its own associations and information. By reproducing each image in color that gives photographs their distinction and uniqueness.

The rarity of seeing signed *Camera Work* gravures and the striking individuality of each artist's handwriting (reproduced here) revivifies what we sometimes take for granted. Lastly, images by artists like J. Walter Collinge, Charles Conlon, and the James Studio are almost unknown, but these striking photographs not only hold their own, but whet our appetite for further glimpses of what they were capable of creating.

What all of these images have in common is the nearly undefinable factor that makes the viewing of each a visceral and arresting visual experience. We know, however, that the skill, motivation, and picture-making ability of each artist comprise a vision. There is also a charm to much of the work of this period which had little to do with nostalgia. It comes from the freshness and innocence of doing things first—and the pleasure taken in the results.

In his book *An American Century of Photography: From Dry-Plate to Digital,* Keith Davis questions what is most "American" about American photography and suggests the following themes as most indicative: the tensions between nature and technology, pragmatism and idealism, science and faith, high and popular culture, political unity and diversity, and individuality and community. I would add (using the subtitles of the shows that preceded this book) photographs and visions (the attempt to carve a consistent photographic vision out of quintessentially American material), and observations and metaphors (the creation of metaphor from that vision or observation).

If the first third of the American century set the stage for the explosion of possibilities open to American photographers from 1936 onwards, nothing could have quite prepared their players for the dominant role American photography would assume in the second third of the century. As America consolidated its place as the world's major power, the opportunities for photographers grew. From the birth of *LIFE* in 1936 to the governmental support of photography in the Farm Security Administration, to the flourishing regional schools that sprang up in Chicago (around Moholy Nagy and the Institute of Art), in California (Weston and the f.64 school), and in New York (initially with

the Photo League, and separately under the mentoring influence of Brodovich, and lastly with W'nogrand's forays on the street), the vitality and breadth of the medium were astonishing.

At the same time, the aesthetic development of photography continued at breakneck speed. Building on the pictorial and modern traditions of the first third of the century, photography became more subjective, more political, more individual, more improvisational. The hand-held camera opened up a whole new world, both literally and figuratively. The uniquely original but relatively straightforward vision of photographer like Edward Weston and Walker Evans gave way to the gently experimental point of view of Henry Callahan and to the iconoclastic testimony of photographers like Robert Frank and William Klein. By the mid-1960s, the surreal observations of Garry Winogrand and Lee Friedlander had redefined the conventions of thirty years earlier regarding what a photograph could and could not be. The typical photographic subject had gone from the composed and intellectually and emotionally clear to a seemingly (but not) random moment requiring thought, interpretation, and knowledge of the artist's intent.

The pleasure of looking at pictures covering such a broad period includes not only observing the traditions and subjects constantly in dialogue with each other but also understanding the intimations of the future each image carries within itself. Was Robert Frank aware of Dorothea Lange's *The Road West?* Did Lee Friedlander know of André Kertész's 1945 photograph of his own shadow, or for that matter, Louis Faurer's 1944 sight of his own reflection? Had Irving Penn seen Siskind's photograph *Glove?* In the hands of each photographer, the subjects take on new meaning, enriching both precursor and follower.

In the first part of the trilogy, I put forward the idea that in the first third of the twentieth century, contrary to the perceived notion of the supremacy of European photography, the continuous stream of creativity and imagination in American photography was overwhelming. Walker Evans practically reinvented the form with his experimental questioning of the human condition and observation of man's mark on his environment. Harry Callahan's quiet observation of the internal and external events of his immediate environment, whether in his series of photographs of his wife Eleanor, or his observations of nature and the city, showed his ability to master a wide range of interests.

In the final third of the century, American photography again led the way, this time in a transformative experience as great as any since the leap from cased objects to images on paper. This time, the transformation was of scale, diversity, and confidence. In 1968, the majority of contemporary photographers were working on a fairly intimate scale—eleven by fourteen inches—and smaller was the norm. If museums showed photography, it was an anomaly. If collectors hung photographs, it was likely to be in their libraries or along a staircase. The same metal sectional frames were recycled from show to show. By 1998, aided by a twenty-year trend of returning to large-view cameras and a complete change in how photography was presented, photographs were often printed as large as forty by fifty inches (and larger). Every major American museum had a fully fledged photography department, and photographs were increasingly taking the place of paintings in the living rooms of an increasingly sophisticated and learned connoisseur class.

Artists like Cindy Sherman, art school graduates without a specific background in photography, were turning to the medium as a means of expression. Robert Mapplethorpe (who also came out of a painting rather than photographic education) would only show his work in a mixed media setting and progressively made ever larger and more elaborately framed pieces. The response was ecstatic. In the 1980s, editions of photographs by the hottest photographers regularly sold out before their shows even opened.

For the sake of clarity, this volume remains focused on the photographic tradition as it evolved, only including artists from outside that tradition when their work had a significant impact within. The diversity of the field was stunning enough, and with the full emergence of color photography as a viable and accepted form, the challenge to painting and the options open to photographers were greater than ever.

Perhaps one of the greatest influences on photography in the latter third of the century was John Szarkowski. Appointed as head of the photography department of the Museum of Modern Art in New York in 1962, Szarkowski embarked on a highly ambitious program of exhibitions and publications. In *The Photographer's Eye,* he put forward a way of looking at photographs that democratized the medium and paid equal attention to pictures made with commercial, amateur or vernacular intent as to those made as "fine art." He championed the work of Garry Winogrand,

Lee Friedlander, Diane Arbus, Joel Meyerowitz, and William Eggleston. Most importantly, his intellect, showmanship, and passion carried photography into a higher realm.

A decade later, Cornell Capa founded the International Center of Photography, initially as a museum concentrating on what he dubbed "Concerned Photography," but quickly expanding to a broader view of the medium. For the first time in history photography had a museum to itself. Photojournalism, an art hitherto more appreciated outside America, was now more fully integrated into the mainstream of photographic thought. Among the greatest changes in the thinking of photographers in the latter third of the century was the widespread challenge to the notion of a photograph being synonymous with truth. Photographers such as Jerry Uelsmann made this question the central theme of their work, and the notion of staging photographs to simulate reality took an ever stronger hold. Cindy Sherman, Sally Mann, and Tina Barney all dealt with differing aspects of staged reality—from totally fictitious, to life-like reincarnations of reality.

One of the last innovations or renovations of the century was the return to camera-less images. The photogram as practiced by Man Ray had long been out of fashion when Adam Fuss, a British born photographer residing in New York, started experimenting with large color photograms made by manipulating light and liquid. He followed with subsequent series of photograms of flowers, rabbit intestines, and live babies. The results were masterful—painterly, but entirely photographic.

At the end of the century, the main unresolved issue for photography was the digital frontier. With the advent of digital technology, two main factors presented themselves. First, the opportunity to print by the Iris system—a digitally controlled flow of colored ink onto watercolor papers that could be printed to larger sizes; and secondly, the opportunity to retouch, enhance, and manipulate at will.

And so we find ourselves contemplating the future. What has always been the most extraordinary aspect of photography is that, in spite of working with essentially the same equipment, in the hands of the gifted, photography has enabled its artist and practitioners to come up with remarkably distinctive bodies of work. Weston and Sugimoto both used 8x10 view cameras, Arbus and Leibovitz favored the 2 1/4 inch square format, Walker Evans and Bruce Weber both employed medium-format

cameras. What we see in these artists' prints are their ideas, not the results of mechanics, technology, and chemistry.

It seems that in the twenty-first century it is time to reuse the famous phrase reputedly uttered by Paul Delaroche in 1839 on the occasion of his first view of photography: "From today painting is dead!" And yet the victory is not absolute. As photography had dominated the two-dimensional landscape of the larger art world, so has the art world influenced photography. At the end of the twentieth century, it is not too far-fetched to project that the art world's appropriation of photography will once again marginalize the classic tradition of photography.

Just as the progression of the history of art had led further from representational (and accessible) art into the corner of conceptualism, so does photography find itself heading into narrower areas. The all-encompassing visions of photographers like Walker Evans, Harry Callahan, and Robert Frank have given way to the narrower focus of artists like Robert Mapplethorpe and Sally Mann—photographers who mapped out a specific territory or territories and worked within that. This is not a derogatory criticism—artists from Van Eyck to Jackson Pollack have also mined the same ground to profound effect—but it is only logical that the possibilities and ground for original work are rapidly diminishing. Yet it is in the nature of artists, of humans, to find new insights, ideas, openings. What is clear is that "The American Century" is giving way to "The Global Century."

In 1985, I prevailed upon Cornell Capa to write a foreword to a photography book benefitting USA for Africa, and his words seem an appropriate way to end this centennial retrospective. He wrote: "The causes of the decades, the sensibilities of the participants are different. Three things remain constant: the desperate need of humankind, the capacity of photographs to move souls to act, and photographers to help. Perhaps we have learned that it is the constancy of the heart that is our best hope for survival.

[1]
MARGARET BOURKE-WHITE
Transmission Tower Helix
1933
Vintage Gelatin Silver Print
13 x 10 1/2 inches (33 x 26,7 cm)

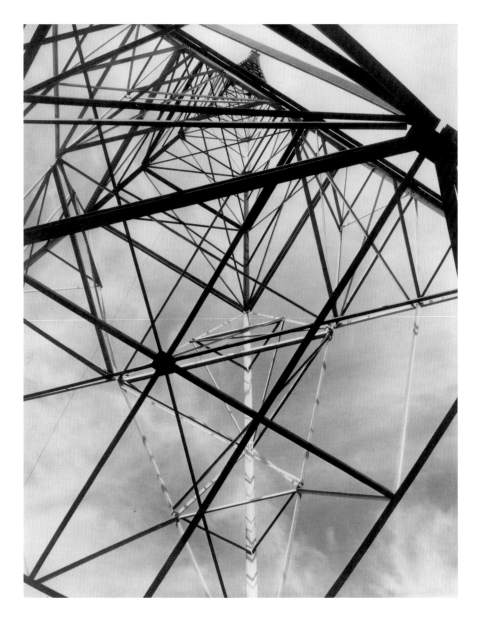

[2]
C L A R E N C E W H I T E
Ring Toss
1899
Signed Photogravure
7 x 5 1/2 inches (17,8 x 14 cm)

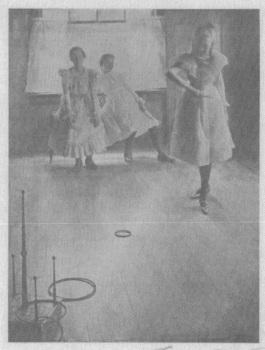

[3]
DETROIT PUBLISHING COMPANY
View of The Grand Canyon
c. 1905
Vintage Platinum Print
15 x 19 inches (38,1 x 48,3 cm)

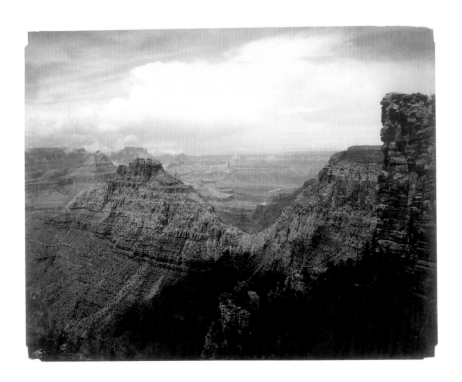

[4]
GERTRUDE KASEBIER
Miss N.
1902
Signed Photogravure
7 3/4 x 5 7/8 inches (19,7 x 14,9 cm)

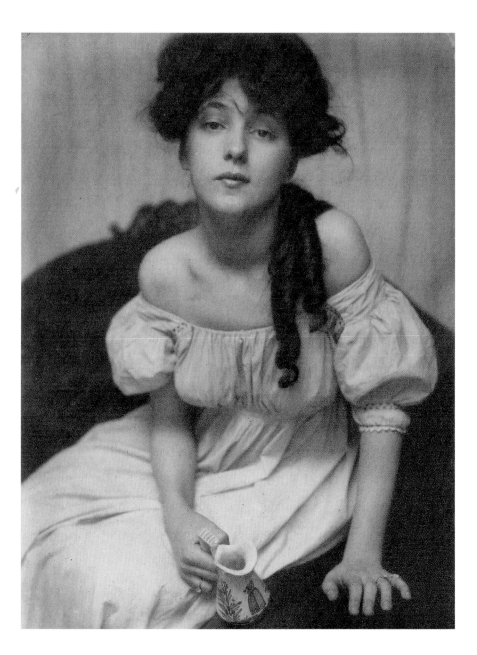

[5]
A L F R E D S T I E G L I T Z
The Flatiron
1902
Signed Photogravure
6 3/4 x 3 1/4 inches (17,1 x 8,3 cm)

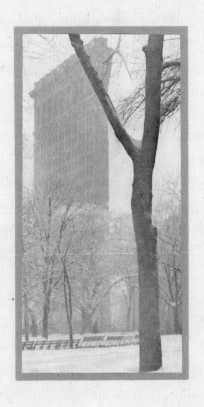

[6]
HARRY C. RUBINCAM
In the Circus
c. 1905
Vintage Gelatin Silver Print
5 7/8 x 10 inches (14,9 x 25,4 cm)

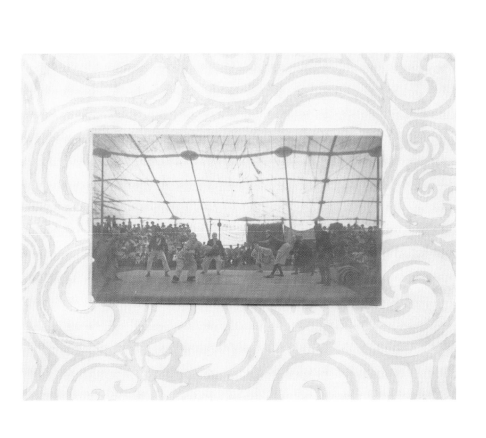

[7]
E D W I N H A L E L I N C O L N
Blue Eyed Grass
1905
Vintage Platinum Print
9 1/2 x 7 3/8 inches (24,1 x 18,7 cm)

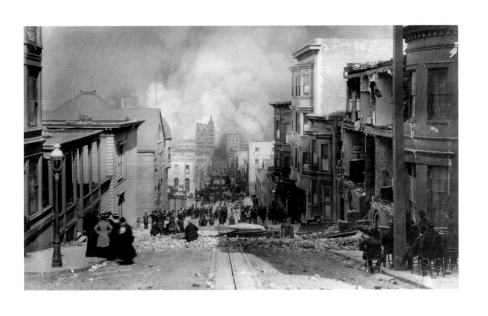

[9]
G E O R G E H E N R Y S E E L E Y
Nude–The Pool
1909
Vintage Platinum Print
11 x 14 inches (27,9 x 35,6 cm)

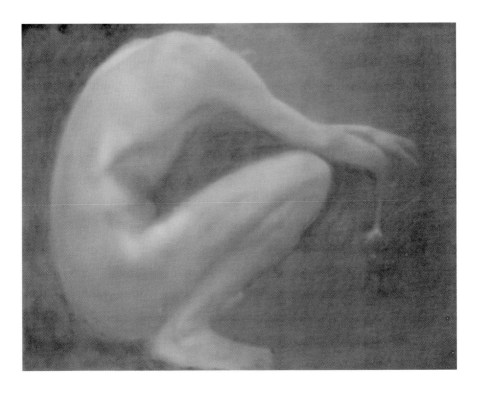

[10]
J A M E S H A R E
Orville Wright Taking Off
1908
Vintage Toned Gelatin Silver Print
3 x 5 inches (7,6 x 12,7 cm)

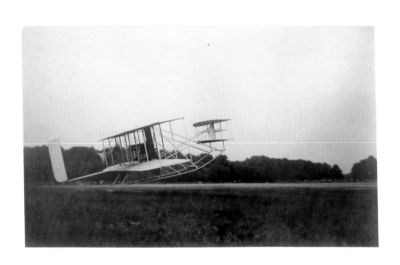

[11]
E D W A R D S H E R I F F C U R T I S
Waiting in the Forest
1910
Vintage Photogravure
15 1/2 x 11 inches (39,4 x 27,9 cm)

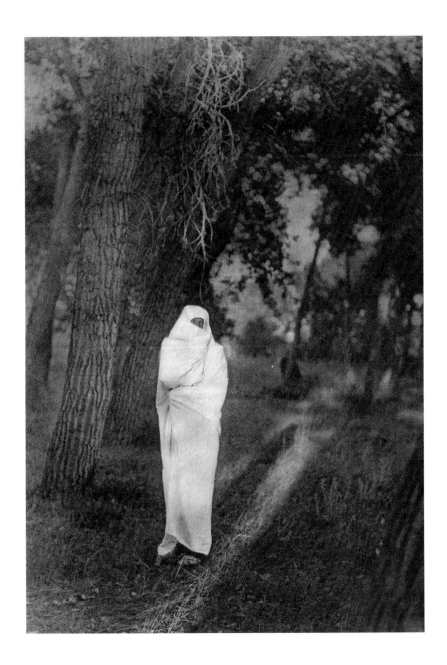

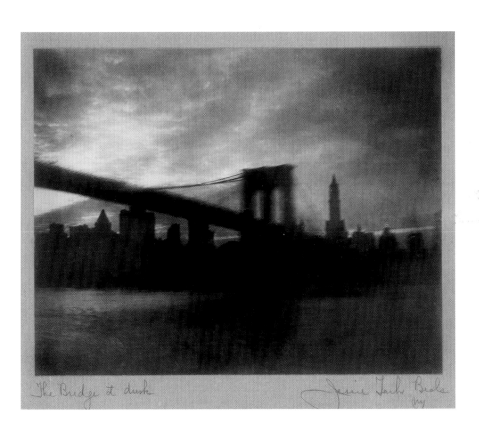

The Bridge at dusk Jessie Tarbox Beals
 NY

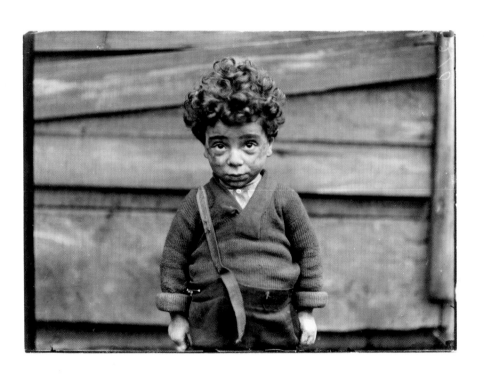

[14]
KARL STRUSS
116th Street Looking West
1911
Vintage Platinum Print
4 5/8 x 3 3/4 inches (11,7 x 9,5 cm)

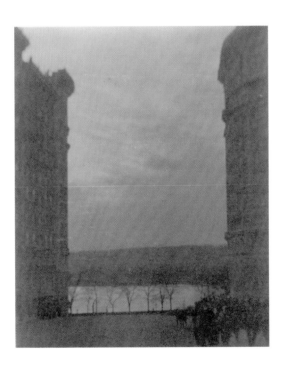

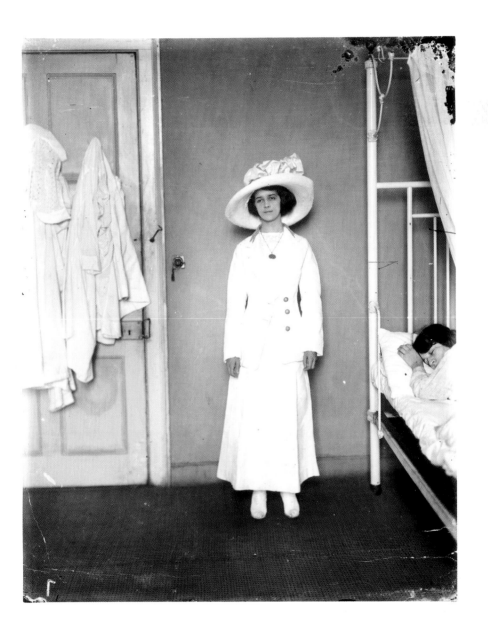

[16]
B E R N A R D H O R N E
Still Life
1916
Vintage Platinum Print
7 1/8 X 6 inches (18,1 x 15,2 cm)

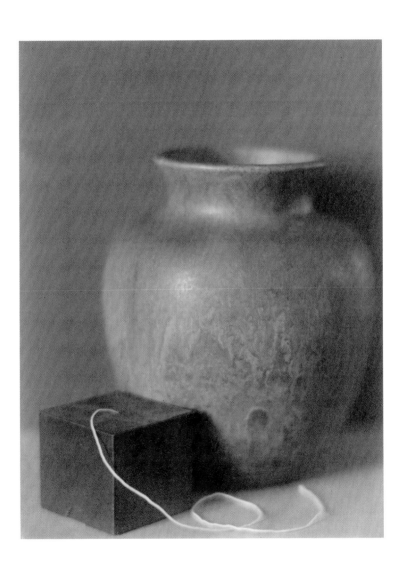

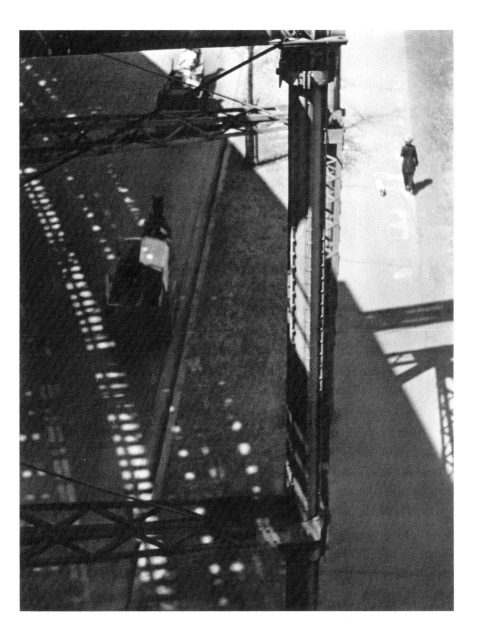

[18]
A L F R E D S T I E G L I T Z
Ellen Koeniger, Lake George
1916
Vintage Toned Gelatin Silver Print
7 1/2 x 9 1/4 inches (19 x 23,5 cm)

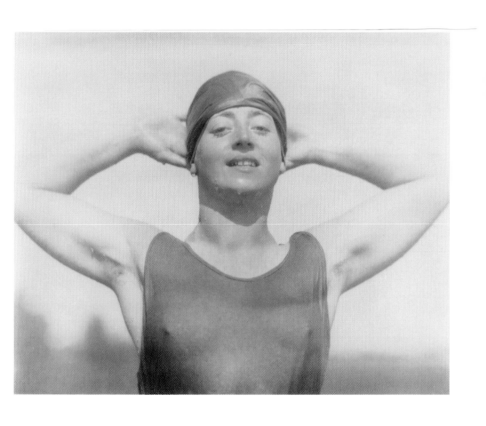

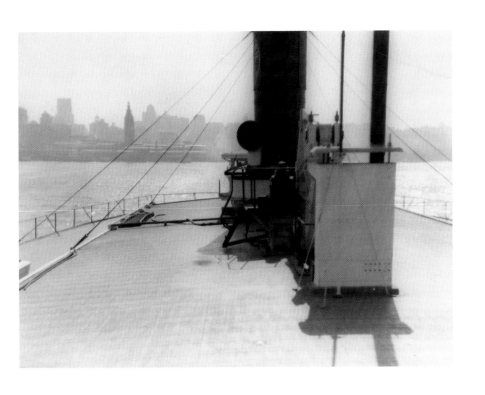

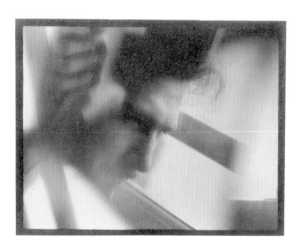

[21]
M A Y H A R T S T U D I O
A Living Flag (Great Lakes Recruit)
1917
Vintage Gelatin Silver Print
14 x 11 inches (35,6 x 27,9 cm)

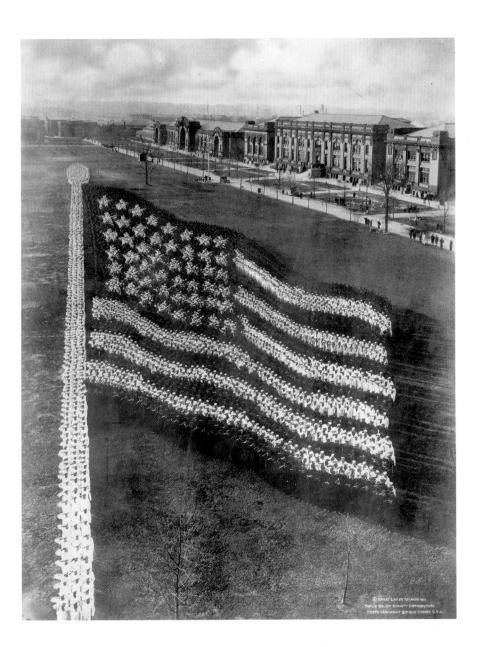

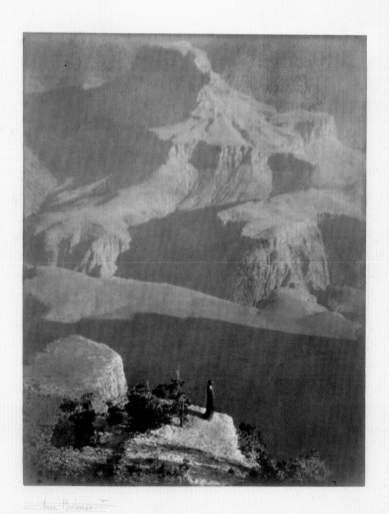

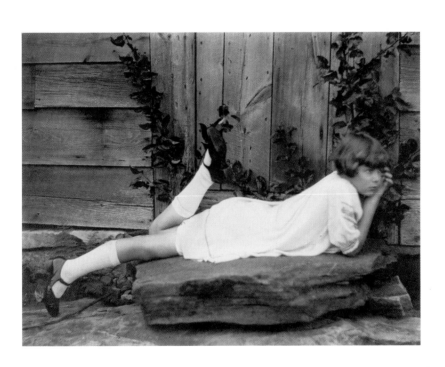

[24]
R A L P H S T E I N E R
Madison Square Garden Tower, New York
1921-1922
Vintage Palladium Print
4 1/8 x 1 1/2 inches (10,5 x 3,8 cm)

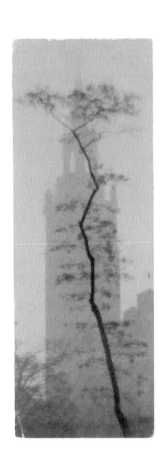

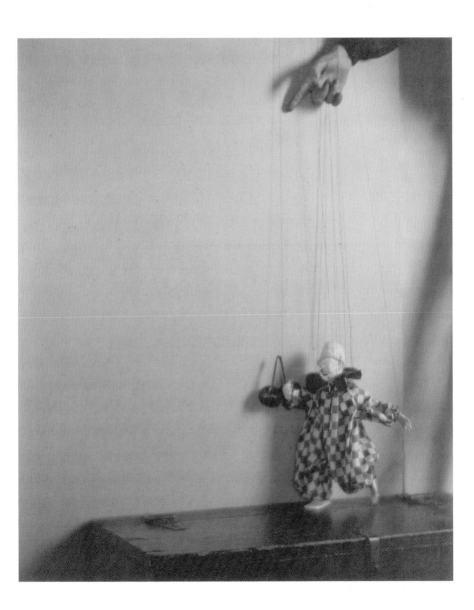

[26]
BARON ADOLPH DE MEYER
Josephine Baker
c. 1922
Gelatin Silver Print
14 x 11 inches (35,6 x 27,9 cm)

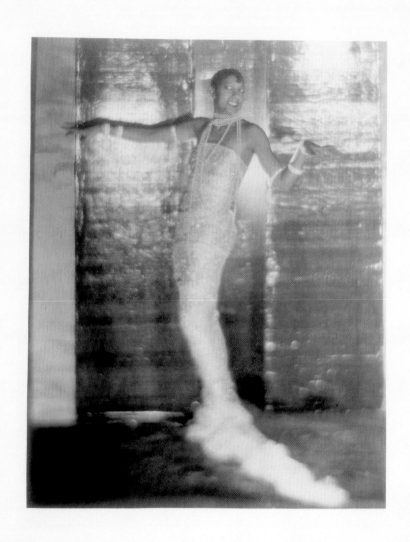

DE MEYER

[27]
E D W A R D W E S T O N
Excusado
1925
Vintage Gelatin Silver Print
9 3/8 x 7 1/2 inches (23,8 x 19 cm)

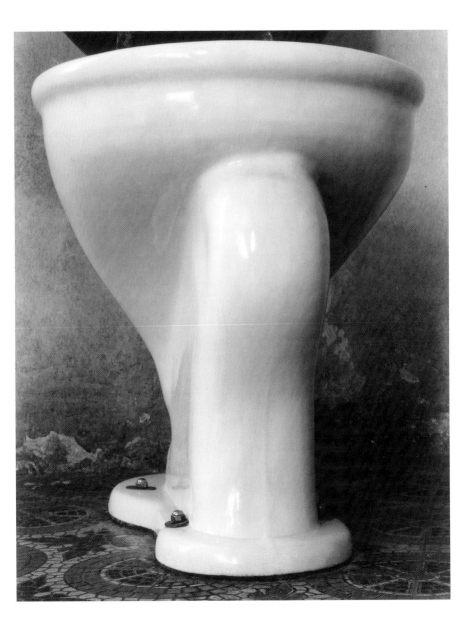

[28]
E D W A R D S T E I C H E N
Anita Chase in a Vionnet Gown
1925
Vintage Gelatin Silver Print
13 7/8 x 11 inches (35,2 x 27,9 cm)

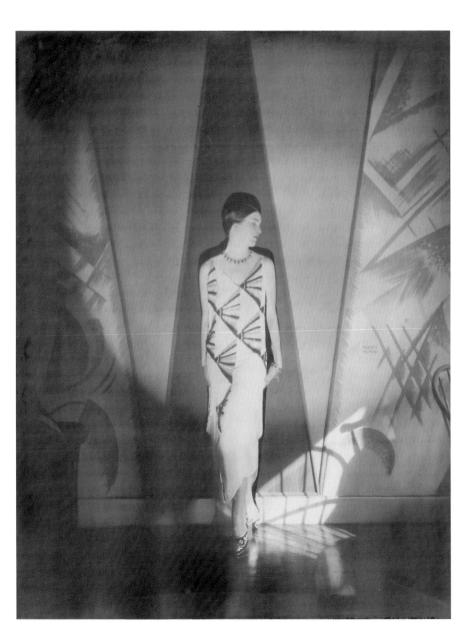

[29]
E D W A R D S T E I C H E N
Spectacles (Abstraction)
1926
Vintage Gelatin Silver Print
8 x 10 inches (20,3 x 25,4 cm)

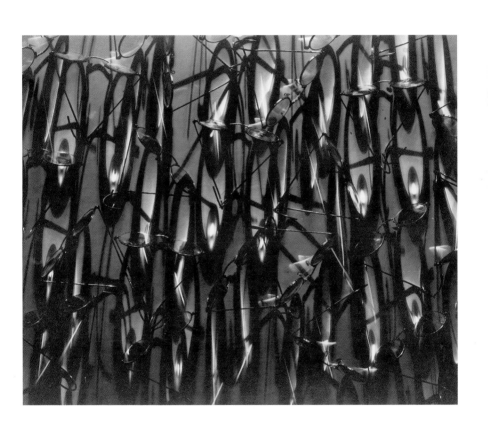

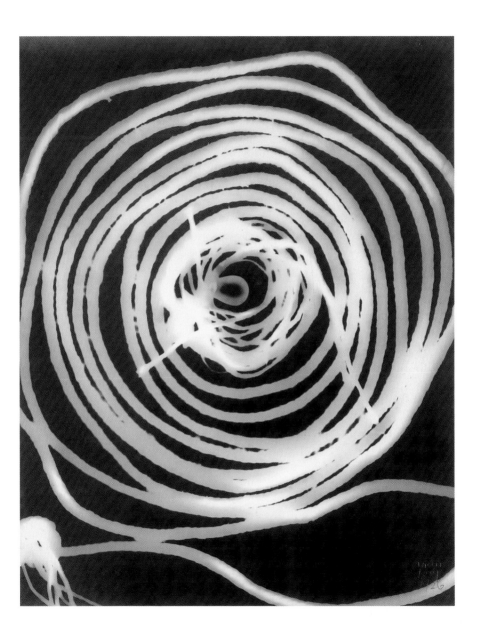

[31]
PAUL OUTERBRIDGE
Semi-Abstraction
1923
Vintage Platinum Print
3 1/2 x 3 inches (8,9 x 7,6 cm)

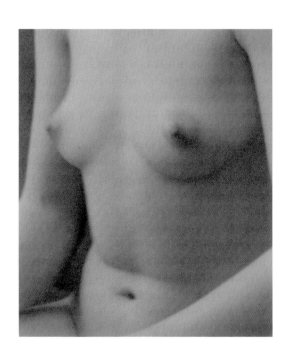

[32]
A L M A L A V E N S O N
Iron Balcony, Biltmore Hotel, Santa Barbara
1929
Unique Vintage Gelatin Silver Print
13 1/2 x 10 inches (34,3 x 25,4 cm)

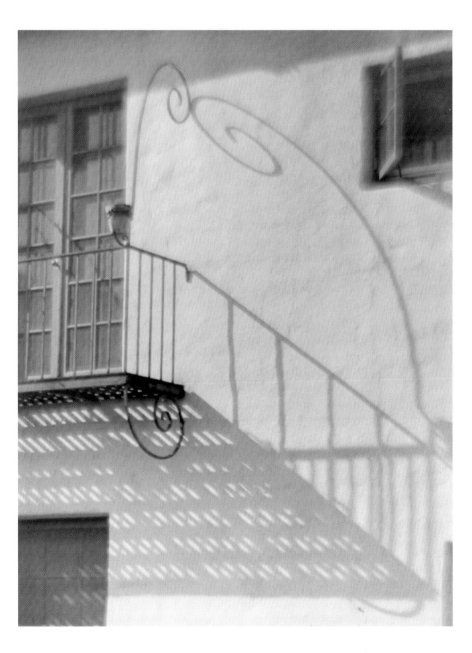

[33]
P A U L S T R A N D
Rebecca, New York
c. 1921
Vintage Platinum Print
10 x 7 3/4 inches (25,4 x 19,7 cm)

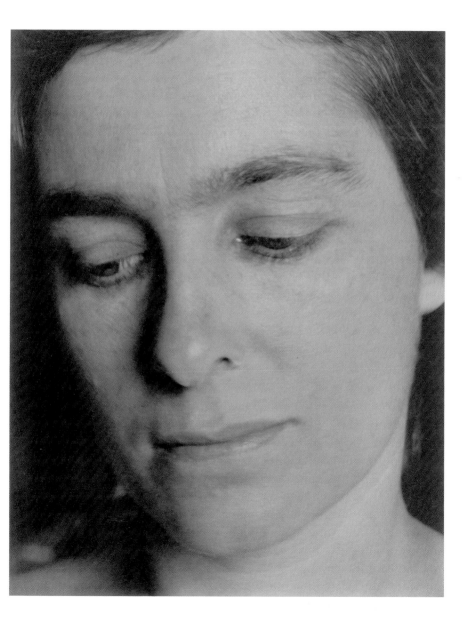

[34]
W A L K E R E V A N S
Untitled
1929
Photogram
11 x 7 inches (27,9 x 17,8 cm)

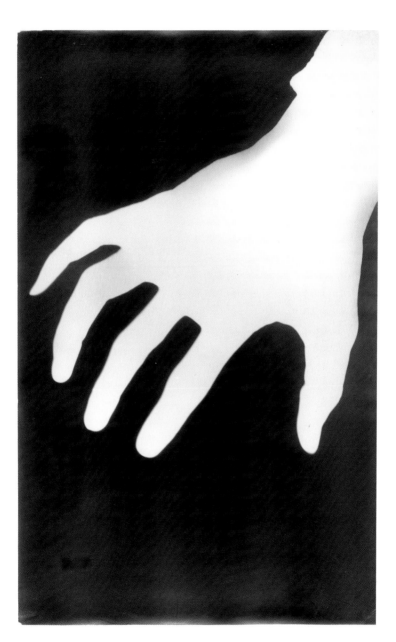

[35]
A L F R E D S T I E G L I T Z
Equivalent
c. 1929
Vintage Gelatin Silver Print
4 1/2 x 3 1/2 inches (11,4 x 8,9 cm)

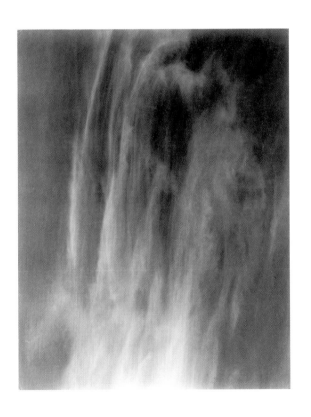

[36]
A N S E L A D A M S
Saint Francis Church, Rancho de Taos, New Mexico
c. 1929
Vintage Gelatin Silver Print
5 1/2 x 7 3/4 inches (14 x 19,7 cm)

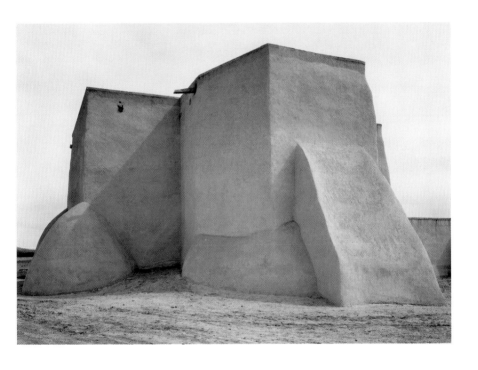

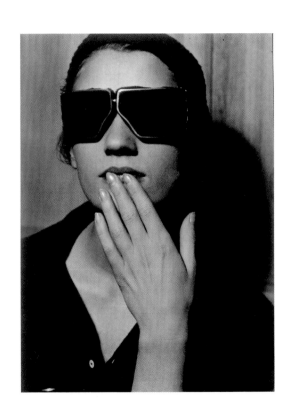

[38]
I M O G E N C U N N I N G H A M
Flax
1930
Vintage Gelatin Silver Print
13 x 8 inches (33 x 20,3 cm)

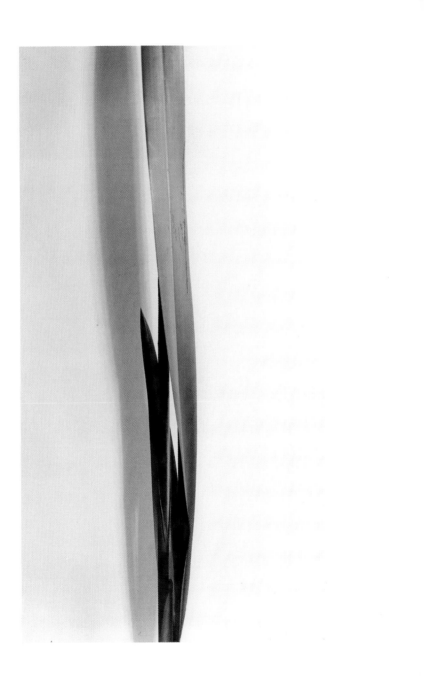

[39]
NICHOLAS MURAY
Christmas Card
1927
Vintage Platinum Print
4 1/4 x 2 7/8 inches (10,8 x 7,3 cm)

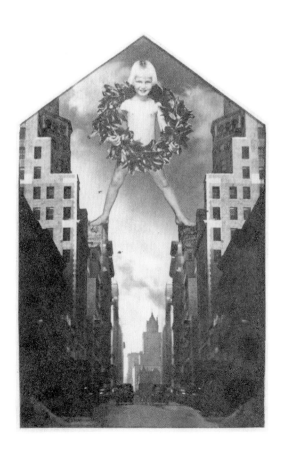

[40]
WENDELL MACRAE
Shadow of Flatiron Building on Madison Square, New York
1930
Vintage Gelatin Silver Print
7 3/4 x 9 1/4 inches (19,7 x 23,5 cm)

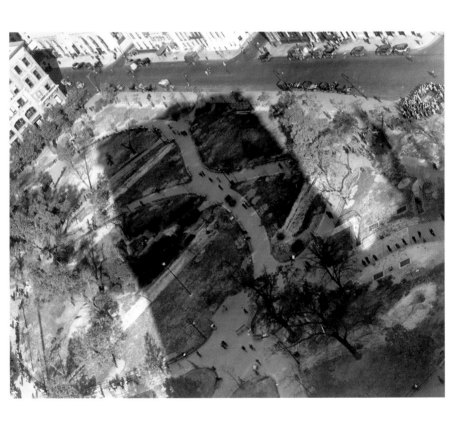

[42]
K U R T B A A S C H
Railroad Signal
c. 1930
Vintage Gelatin Silver Print
9 3/4 x 7 3/8 inches (24,8 x 18,7 cm)

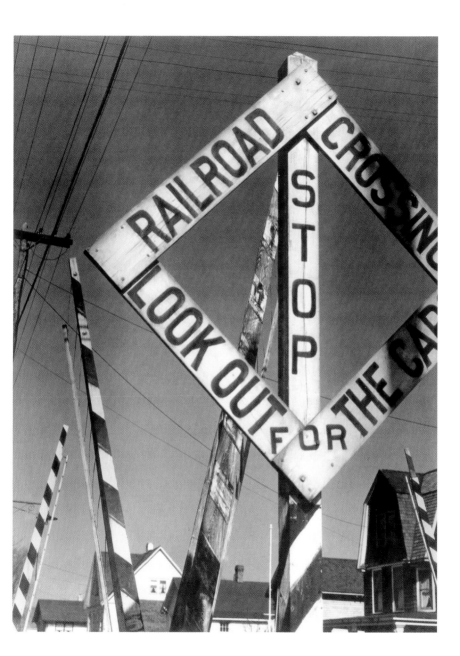

[43]
ANSEL ADAMS
Half Dome, Orchard, Winter, Yosemite
1930
Vintage Gelatin Silver Print
8 x 10 inches (20,3 x 25,4 cm)

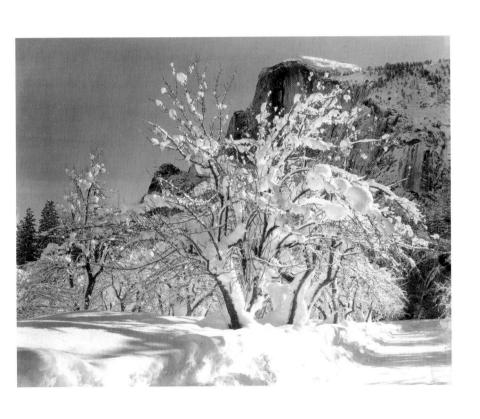

[44]
E D W A R D Q U I G L E Y
Hypothesis
1931
Vintage Gelatin Silver Print
6 3/8 x 4 9/16 inches (16,5 x 12,5 cm)

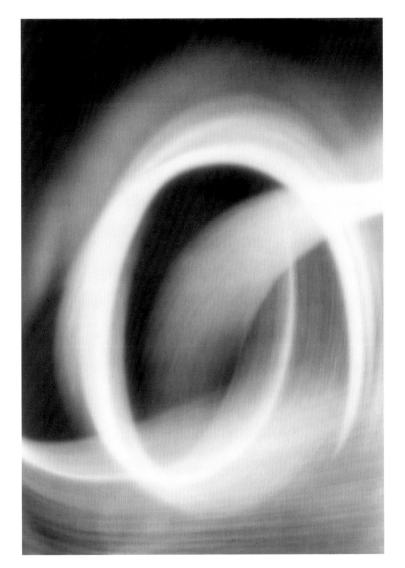

[45]
WALKER EVANS
License Photo Studio, New York
1932
Vintage Gelatin Silver Print
7 1/2 x 6 inches (19 x 15,2 cm)

[46]
IMOGEN CUNNINGHAM
Nude
1932
Vintage Gelatin Silver Print
7 x 9 inches (17,8 x 22,9 cm)

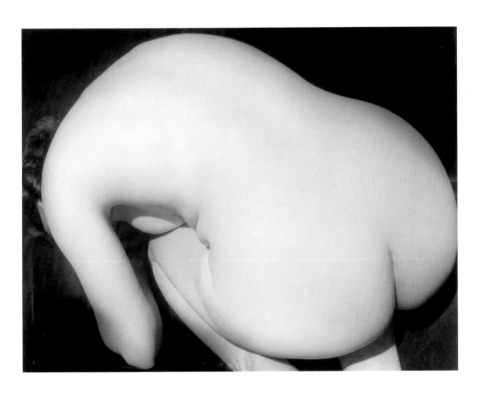

LEWIS W. HINE
Men Working–Empire State Building
1932
Vintage Gelatin Silver Print
11 x 14 inches (27,9 x 35,6 cm)

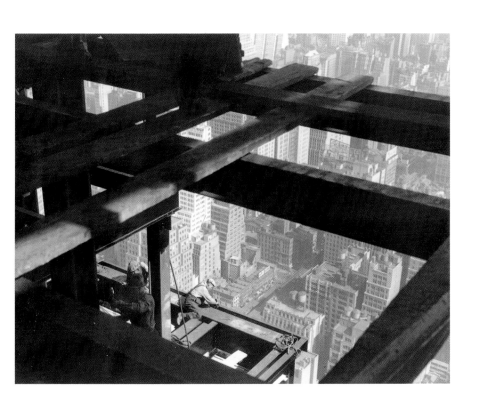

[48]
G E O R G E H U R R E L L
Joan Crawford
1932
Gelatin Silver Print from Retouched Negative
19 3/4 x 16 inches (50,2 x 40,6 cm)

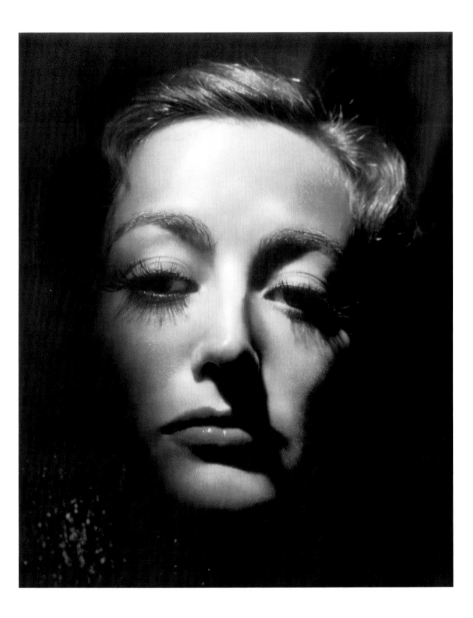

GEORGE HURRELL
Joan Crawford
1932
Gelatin Silver Print from Unretouched Negative
13 x 9 7/8 inches (33 x 25,1 cm)

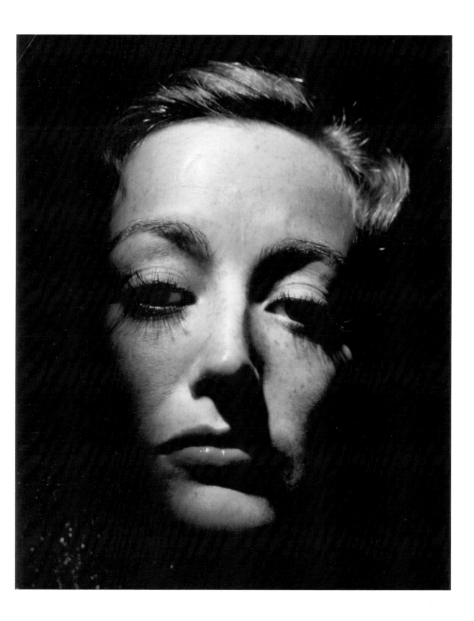

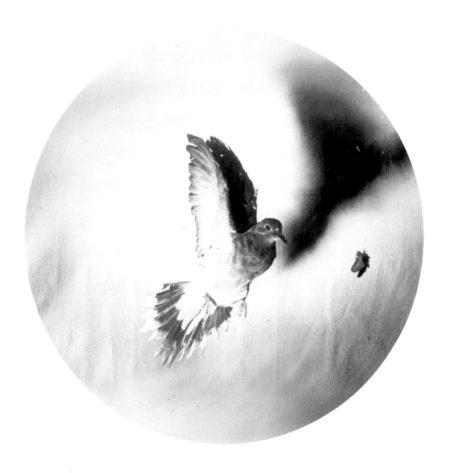

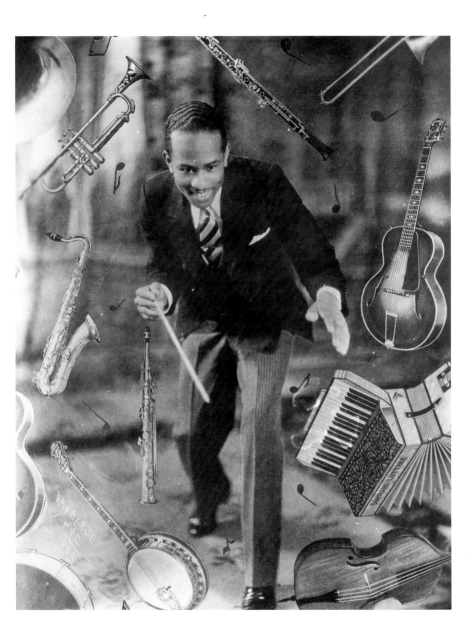

BRETT WESTON
Dunes
1934
Vintage Gelatin Silver Print
10 x 8 1/8 inches (25,4 x 20,6 cm)

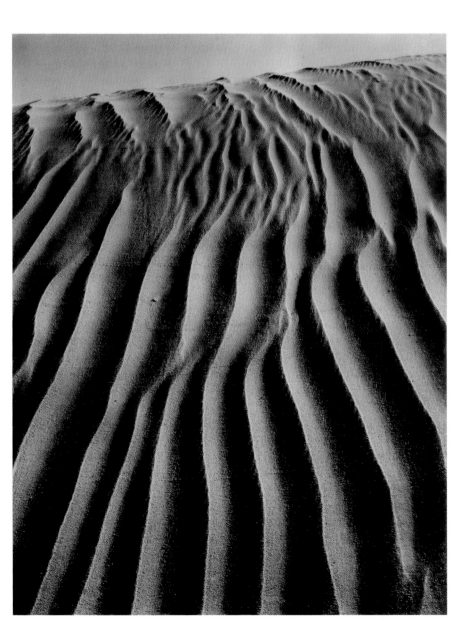

[53]
A L F R E D S T I E G L I T Z
Georgia O'Keeffe, Lake George
1933
Vintage Gelatin Silver Print
7 1/2 x 9 1/2 inches (19 x 24,1 cm)

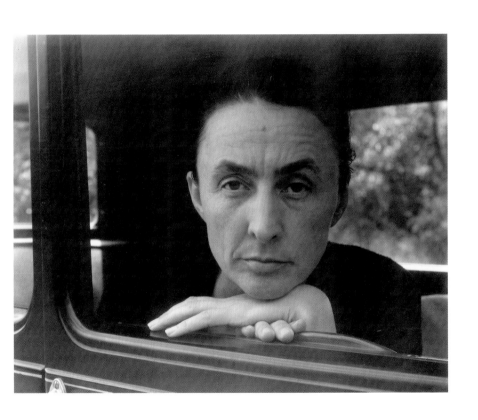

[54]
E D W A R D W E S T O N
Oceano, California
1934
Vintage Gelatin Silver Print
7 1/2 x 9 1/2 inches (19 x 24,1 cm)

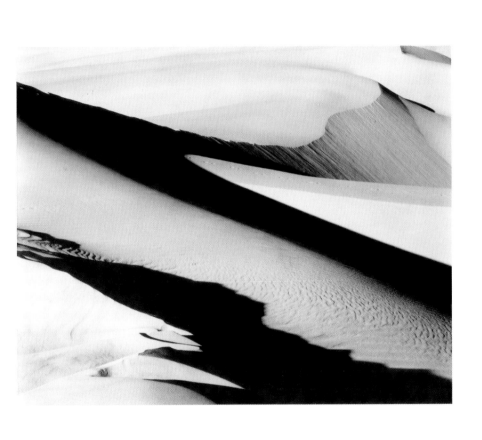

[55]
G E O R G E H O Y N I N G E N - H U E N E
Miss Koopman, Fashion
1934
Vintage Gelatin Silver Print
9 1/2 x 7 inches (24,1 x 17,8 cm)

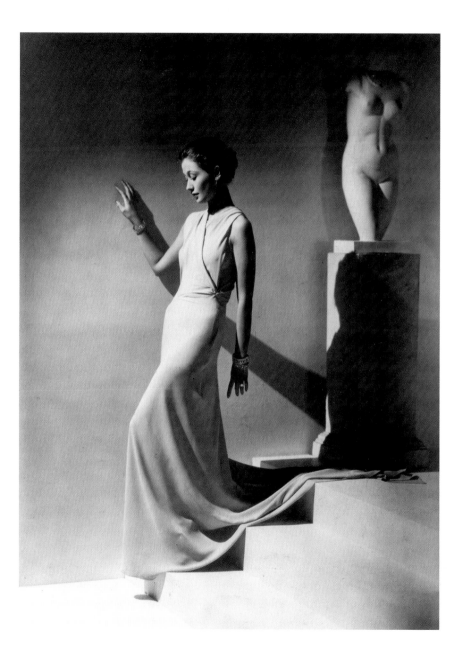

HORACE BRISTOL
Tower of San Francisco Bay Bridge
1935
Vintage Gelatin Silver Print
9 1/2 x 7 5/16 inches (24,1 x 18,6 cm)

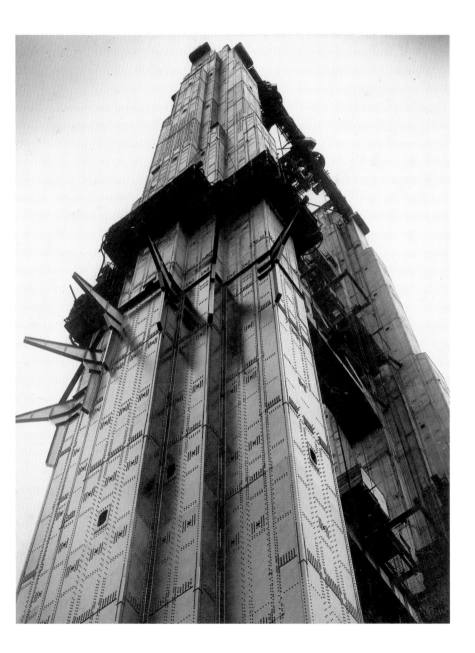

B E R E N I C E A B B O T T
'El' Second and Third Avenue Lines: Looking West from 250 Pearl Street,
Manhattan
1936
Vintage Gelatin Silver Print
9 3/4 x 8 7/8 inches (24,8 x 22,5 cm)

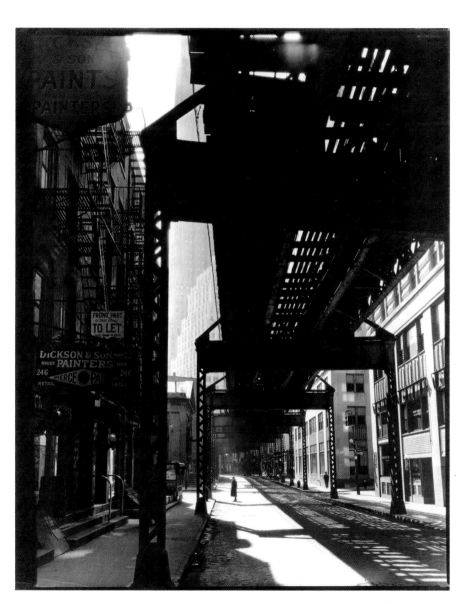

[58]
E D W A R D W E S T O N
Dunes, Oceano
1936
Vintage Gelatin Silver Print
8 x 10 inches (20,3 x 25,4 cm)

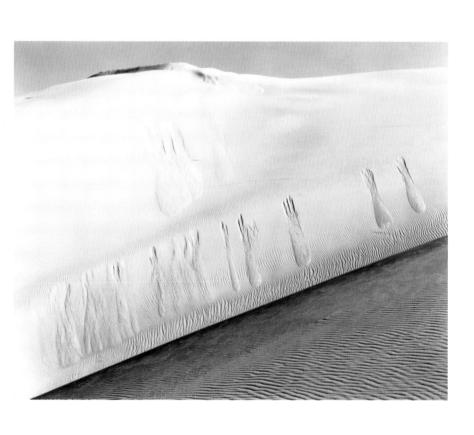

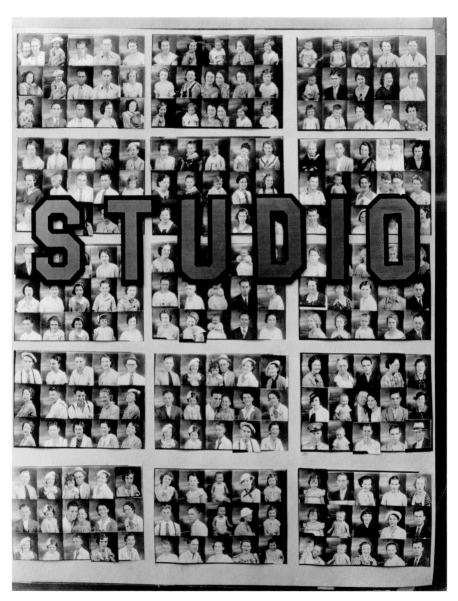

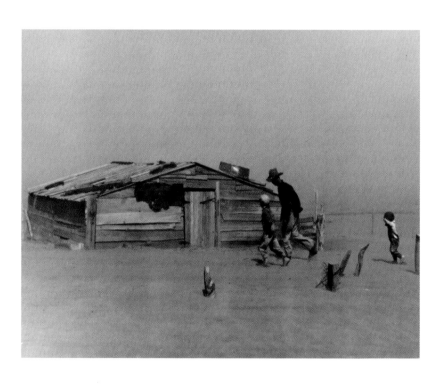

[61]
M A R G A R E T B O U R K E - W H I T E
Construction Workers and Taxi Dancers, Ft. Peck, Montana
1936
Vintage Gelatin Silver Print
13 5/8 x 10 3/8 inches (34,6 x 26,3 cm)

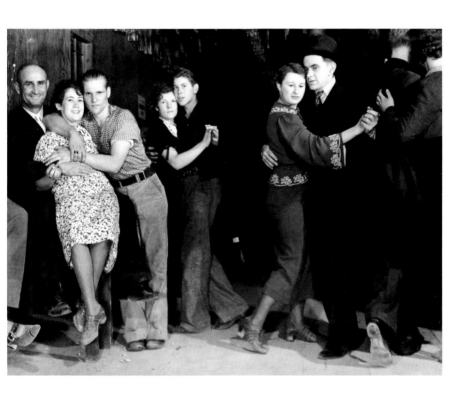

[62]
PAUL OUTERBRIDGE
Images de Deauville
1938
Vintage Color Carbro Print
16 1/4 x 12 1/2 inches (41,3 x 31,7 cm)

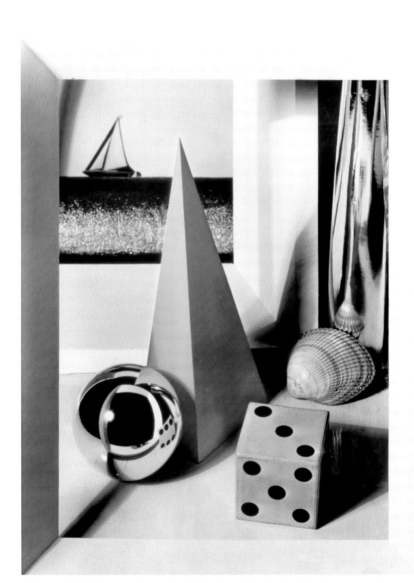

[63]
W A L K E R E V A N S
Silas Green Show, Alabama
1936
Gelatin Silver Print
10 1/2 x 13 9/16 inches (26,7 x 34,4 cm)

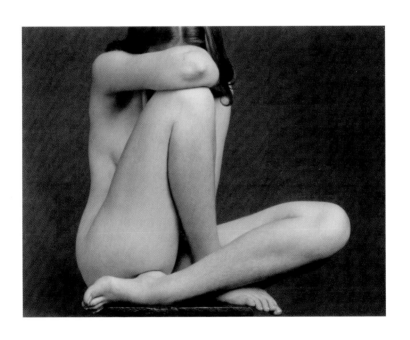

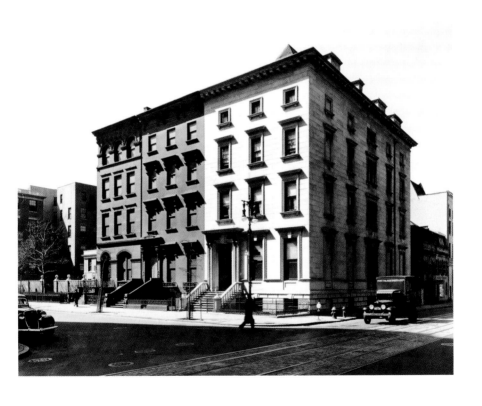

[66]
B R E T T W E S T O N
Broken Window
1937
Gelatin Silver Print
7 9/16 x 9 5/8 inches (19,2 x 24,4 cm)

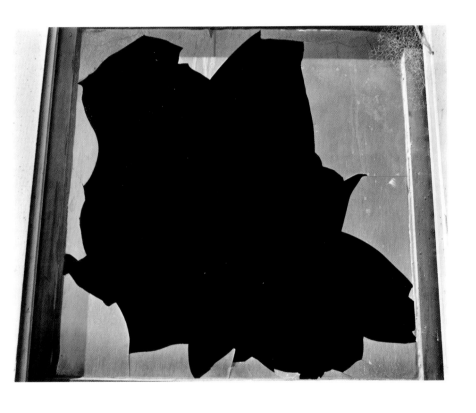

[67]
J O H N G U T M A N N
Jitterbug, New Orleans
1937
Gelatin Silver Print
8 1/8 x 7 1/2 inches (20,6 x 19 cm)

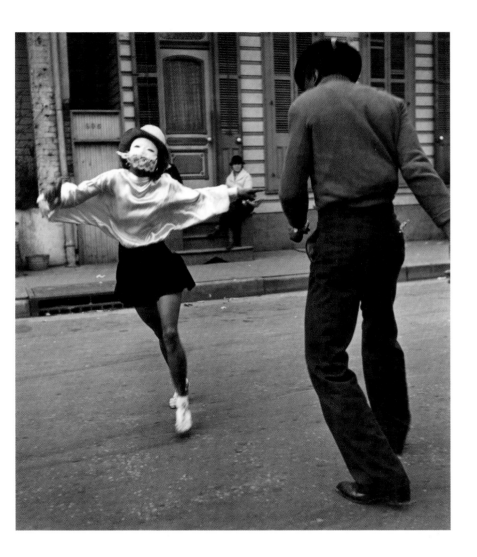

[68]
G Y O R G Y K E P E S
Untitled (Chicago)
c. 1937
Vintage Gelatin Silver Print
10 3/16 x 7 3/4 inches (25,9 x 19,7 cm)

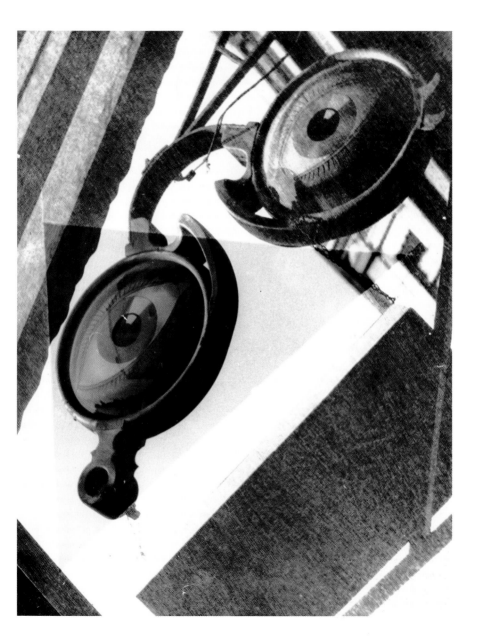

[69]
D O R O T H E A L A N G E
The Road West
1938
Gelatin Silver Print
10 7/16 x 13 3/8 inches (26,5 x 34 cm)

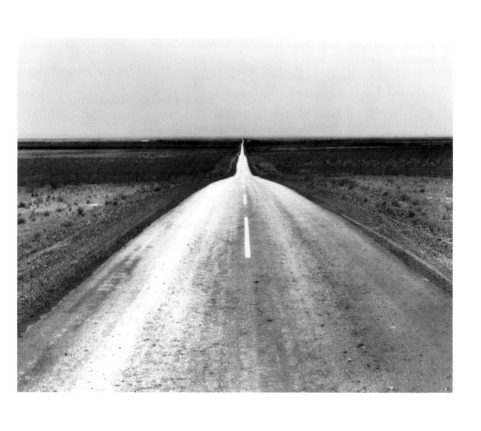

[70]
I L S E B I N G
Wall Street
1936
Vintage Gelatin Silver Print
11 1/8 x 7 15/16 inches (28,3 x 20,1 cm)

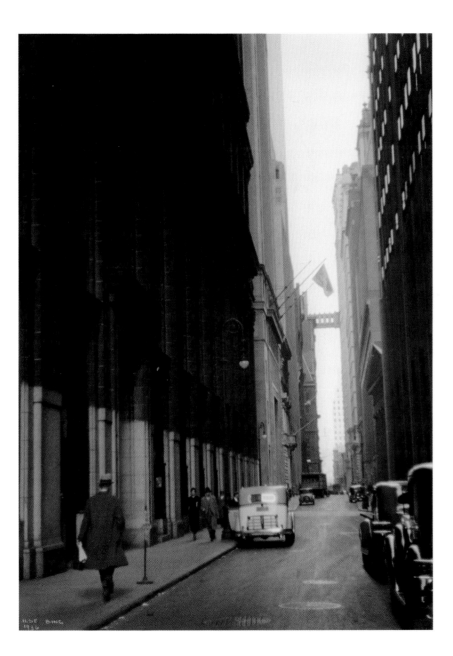

[71]
M A N R A Y
Picasso
c. 1937
Vintage Gelatin Silver Print
10 x 8 inches (25,4 x 20,3 cm)

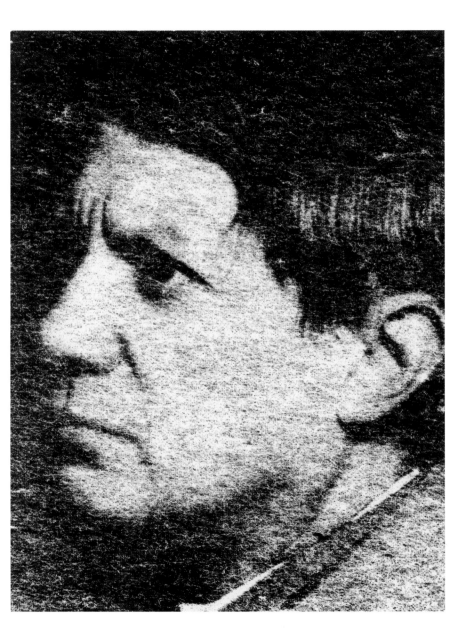

[72]
D O R O T H E A L A N G E
Bulletin Board in Shafter Migrant Camp, California
1938
Vintage Gelatin Silver Print
7 x 9 1/2 inches (17,8 x 24,1 cm)

LEVING. FOR. OKLA
MONDAY. MORNING
WANT. 4 PASSANGERS
Inquire at Evans
grocery store.
Shopton

1930 MODLE
CHEVROLET
SALE.

I am leaving for Missouri
Sun. Oct. 30 by the way of
Oklahoma city can take two passengers
See Herbert Page lot 240

FOR SALE 10.6.12 Tint
and 8 hands tent canvas
Call at Lot 335 Unit 3
Apt 1

[73]
H A R O L D E D G E R T O N
Bobby Jones, Multi-Flash Golf Swing
1938
Vintage Gelatin Silver Print
9 7/16 x 7 9/16 inches (24 x 19,2 cm)

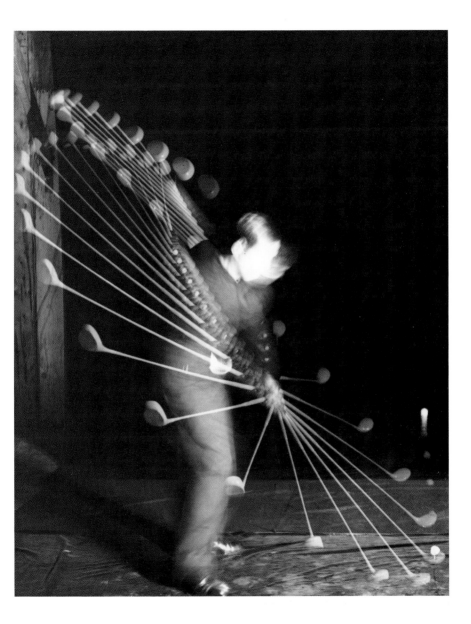

[74]
E D W A R D W E S T O N
Clouds, Death Valley
1939
Vintage Gelatin Silver Print
7 9/16 x 9 1/2 inches (19,2 x 24,1 cm)

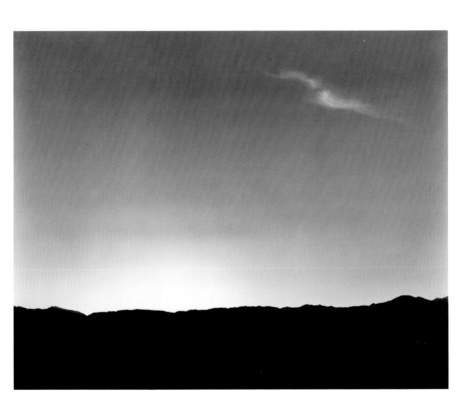

[75]
ANSEL ADAMS
Georgia O'Keeffe and Orville Cox, Canyon de Chelly National Monument, Arizona
1937
Gelatin Silver Print
7 1/2 x 10 inches (19 x 25,4 cm)

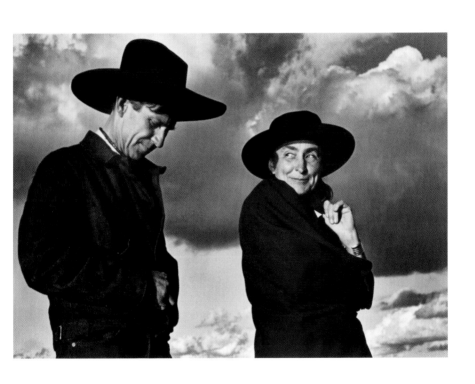

M A R G A R E T B O U R K E - W H I T E
The George Washington Bridge
1939
Vintage Gelatin Silver Print
13 5/8 x 9 inches (34,6 x 22,9 cm)

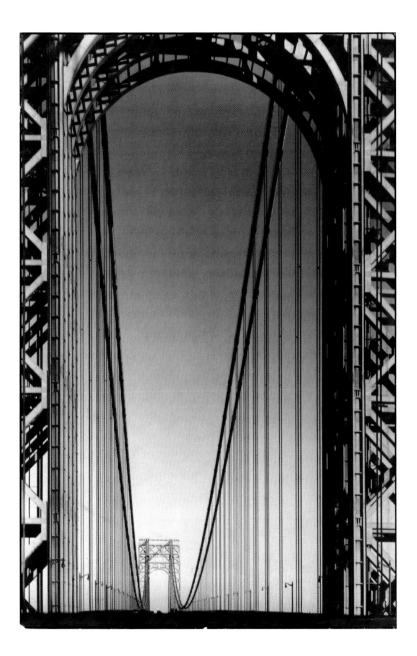

[77]
G E O R G E P L A T T L Y N E S
Alfred Herrick
c. 1940
Vintage Gelatin Silver Print
9 x 7 3/8 inches (22,9 x 18,7 cm)

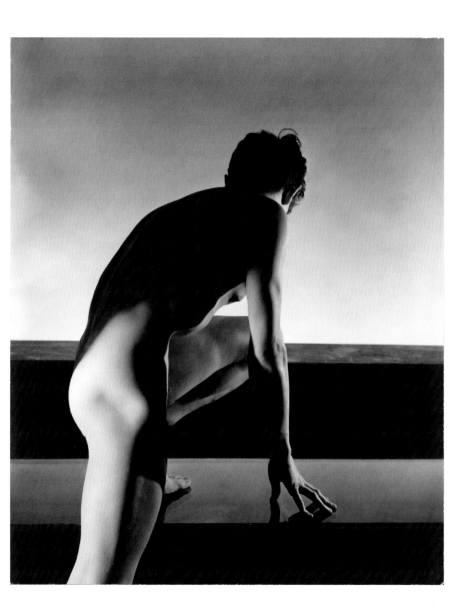

[78]
L A S Z L O M O H O L Y - N A G Y
Fotogram
1946
Vintage Gelatin Silver Print
13 7/8 x 11 inches (35,2 x 27,9 cm)

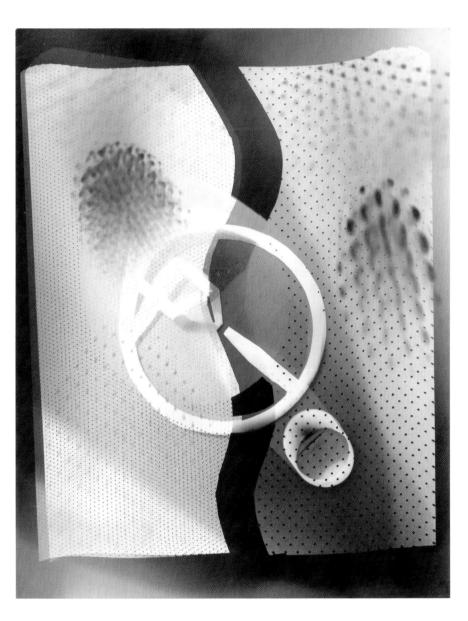

LISETTE MODEL
42nd Street from the Sixth Avenue Subway (Running Legs), New York
1942
Vintage Gelatin Silver Print
10 7/8 x 13 1/2 inches (27,6 x 34,3 cm)

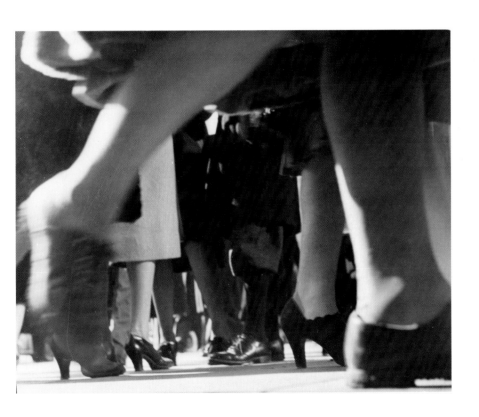

[80]
A N S E L A D A M S
Moonrise Over Hernandez
1944
Vintage Gelatin Silver Print
20 x 24 inches (50,8 x 61 cm)

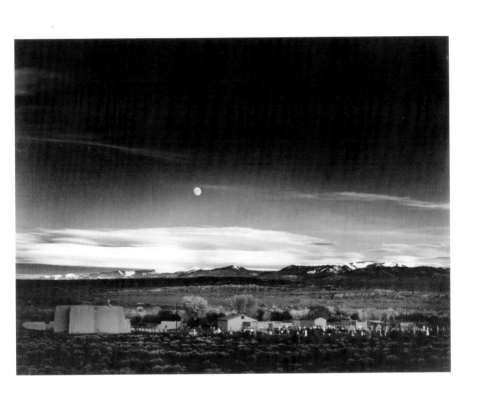

[81]
W E E G E E
Their First Murder
October 9, 1941
Vintage Gelatin Silver Print
8 15/16 x 9 1/2 inches (22,7 x 24,1 cm)

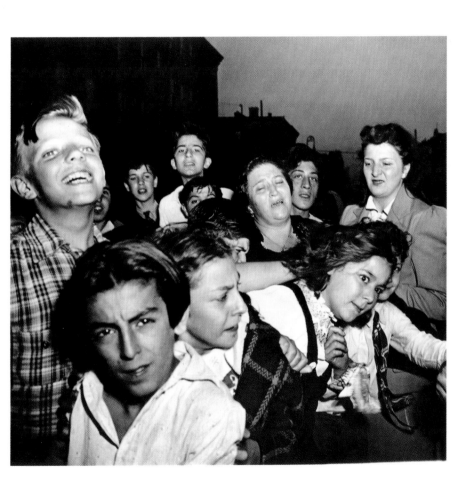

[82]
R O Y P A R T R I D G E
Pepper Tree Pattern
1941
Vintage Gelatin Silver Print
10 7/16 x 12 3/8 inches (26,5 x 31,4 cm)

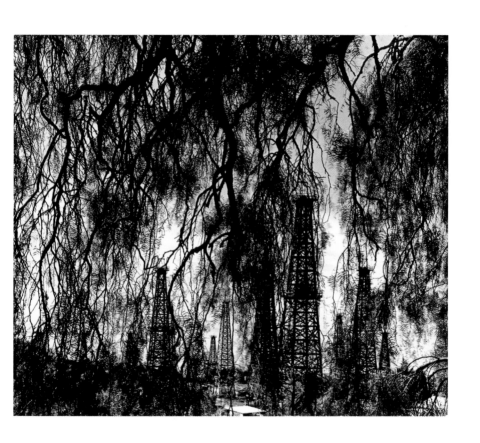

[83]
G E O R G E H U R R E L L
Jane Russell in "The Outlaw"
1941
Vintage Gelatin Silver Print
13 7/8 x 10 1/2 inches (35,2 x 26,7 cm)

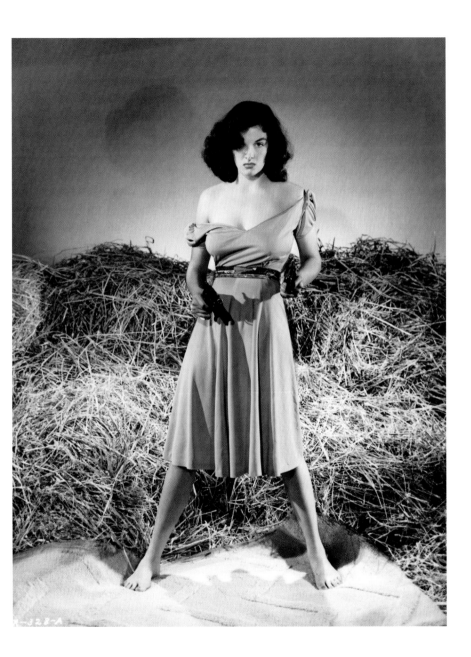

[84]
F A U R E S T D A V I S
The Clown
1942
Vintage Gelatin Silver Print
8 x 10 inches (20,3 x 25,4 cm)

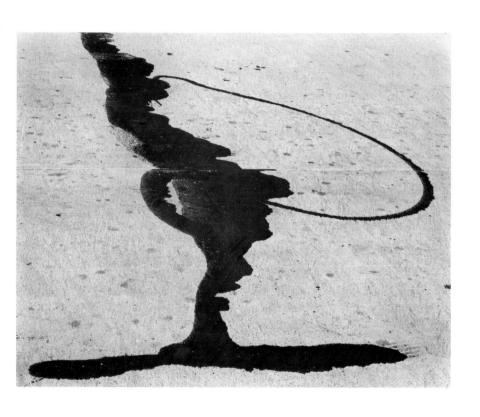

[85]
H E L E N L E V I T T
Untitled
1940
Vintage Gelatin Silver Print
7 3/4 x 9 3/4 inches (19,7 x 24,8 cm)

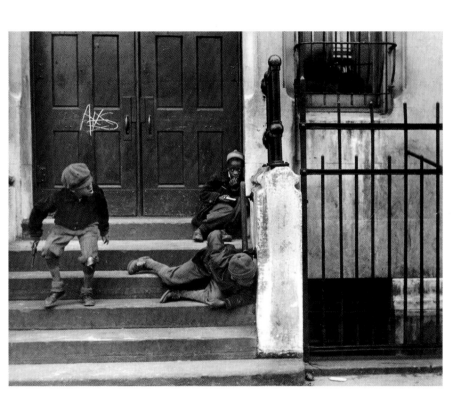

[86]
HARRY CALLAHAN
Camera Movement on Flashlight
1947
Vintage Gelatin Silver Print
4 1/2 x 3 3/8 inches (11,4 x 8,6 cm)

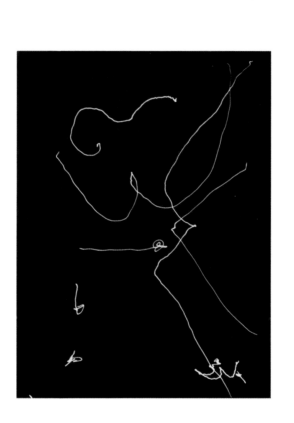

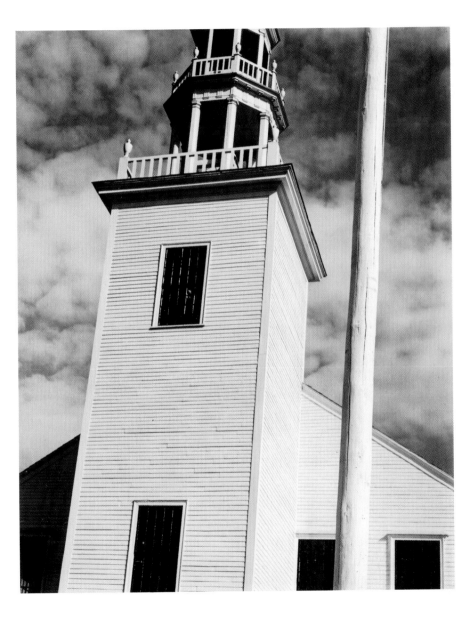

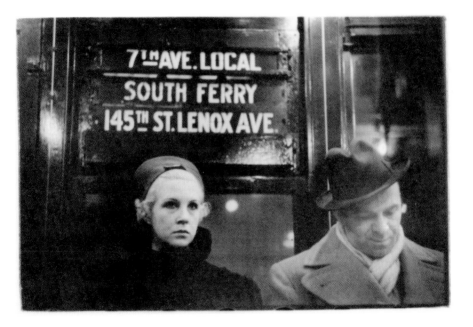

[89]
A A R O N S I S K I N D
Gloucester
1944
Vintage Gelatin Silver Print
9 1/2 x 7 1/2 inches (24,1 x 19 cm)

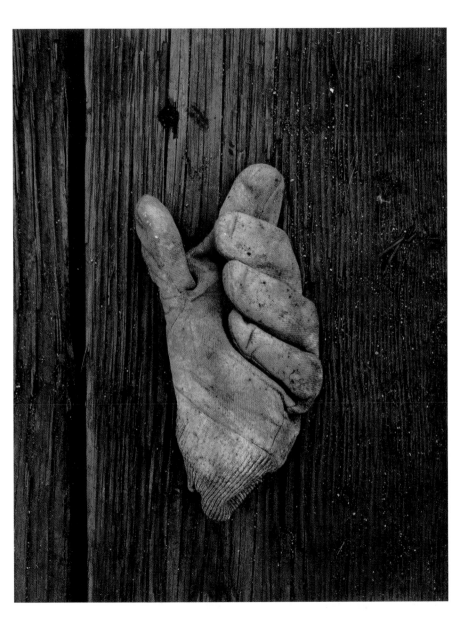

[90]
R O B E R T C A P A
American Troops Landing on D-Day, Omaha Beach, near Colleville-sur-Mer,
Normandy Coast
June 6, 1944
Gelatin Silver Print
6 5/16 x 9 5/8 inches (16 x 24,4 cm)

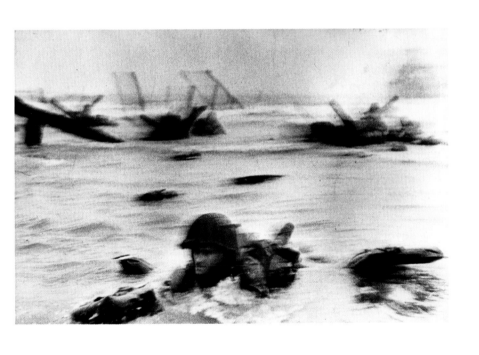

[91]
HARRY CALLAHAN
Chicago
c. 1950
Vintage Gelatin Silver Print
8 5/8 x 9 5/8 inches (21,9 x 24,4 cm)

[92]
J O E R O S E N T H A L
Raising the Flag on Mount Suribachi, Iwo Jima
February 23, 1945
Vintage Gelatin Silver Print
9 1/2 x 7 1/2 inches (24,1 x 19 cm)

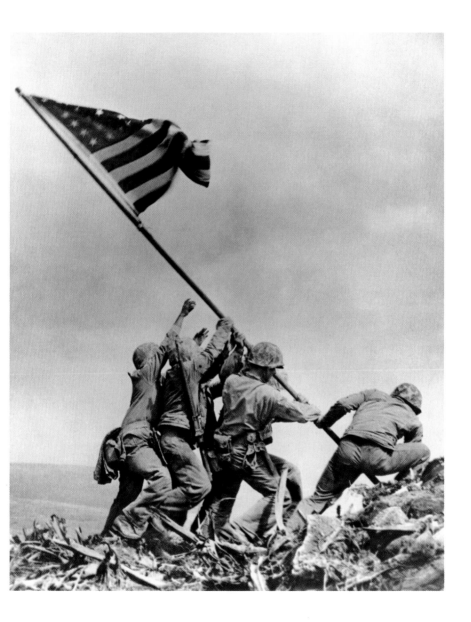

[93]
A R N O L D N E W M A N
Igor Stravinsky
1946
Gelatin Silver Contact Print with Pre-visualized Crop Marked in the
Artist's Hand
4 x 5 inches (10,2 x 12,7 cm)

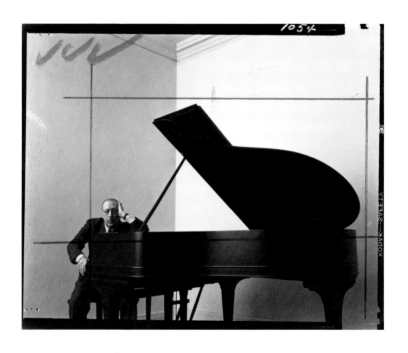

[94]
RICHARD AVEDON
Renée, The New Look of Dior, Place de la Concorde, Paris
August, 1947
Gelatin Silver Print
17 5/8 x 14 1/8 inches (44,8 x 35,9 cm)

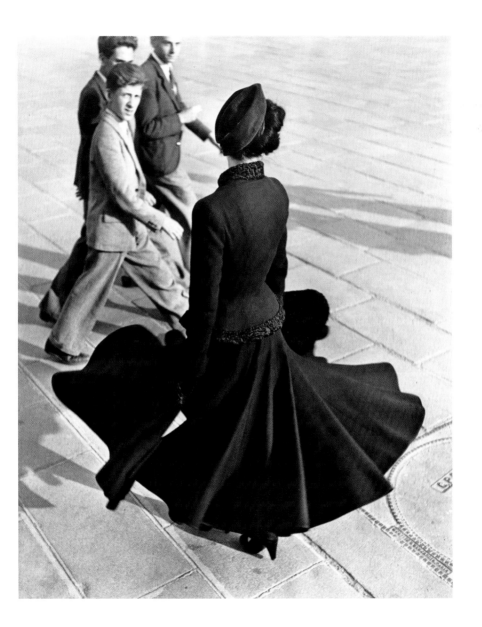

[95]
A N D R E A S F E I N I N G E R
View of New York from New Jersey
1948
Vintage Gelatin Silver Print
20 x 24 inches (50,8 x 61 cm)

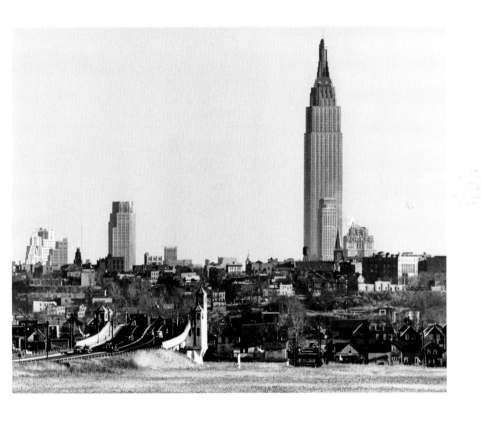

W E E G E E
Audience in the Palace Theater
c. 1950
Vintage Gelatin Silver Print
7 x 9 inches (17,8 x 22,9 cm)

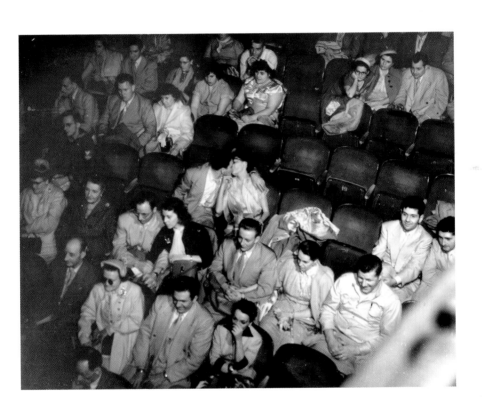

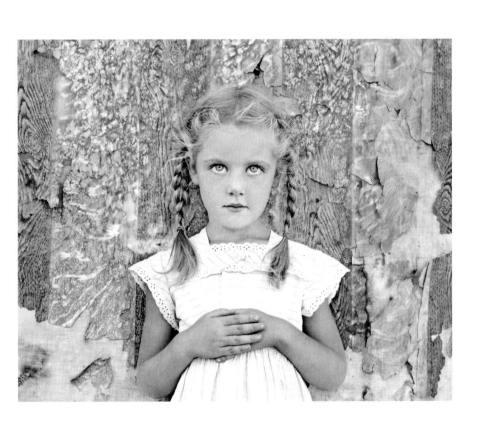

[98]
IRVING PENN
The Most Photographed Models of 1947
1947
Vintage Gelatin Silver Print
16 x 20 inches (40,6 x 50,8 cm)

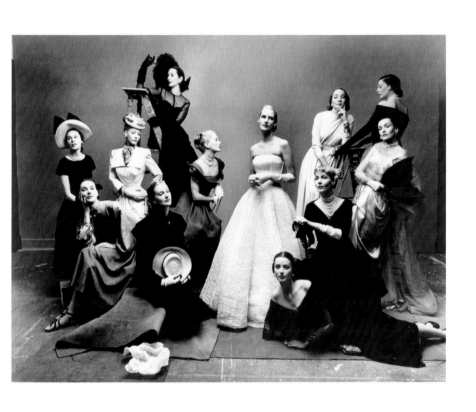

[99]
HARRY CALLAHAN
Eleanor, Chicago
c. 1947
Vintage Gelatin Silver Print
4 9/16 x 3 5/16 inches (12,5 x 8,4 cm)

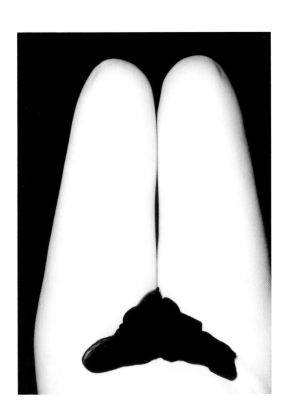

[100]
PAUL HIMMEL
Grand Central Station
c. 1940
Gelatin Silver Print
16 x 20 inches (40,6 x 50,8 cm)

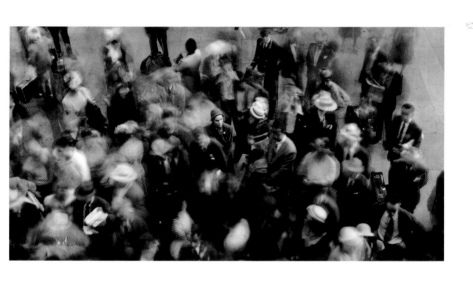

[101]
A N D R É K E R T É S Z
Long Island
c. 1945
Vintage Gelatin Silver Print
10 x 8 inches (25,4 x 20,3 cm)

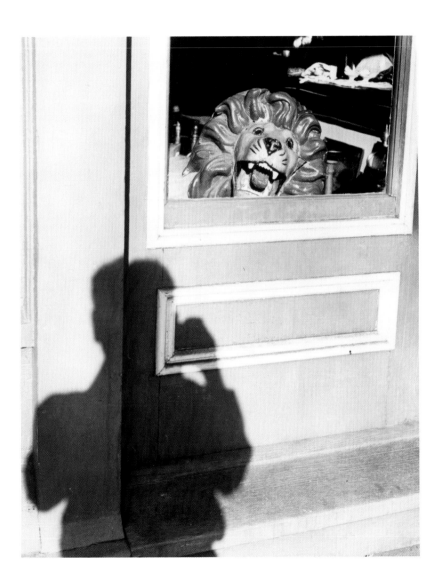

[102]
BARBARA MORGAN
Lloyd's Head
1948
Vintage Gelatin Silver Print
16 3/4 x 12 1/8 inches (42,5 x 30,8 cm)

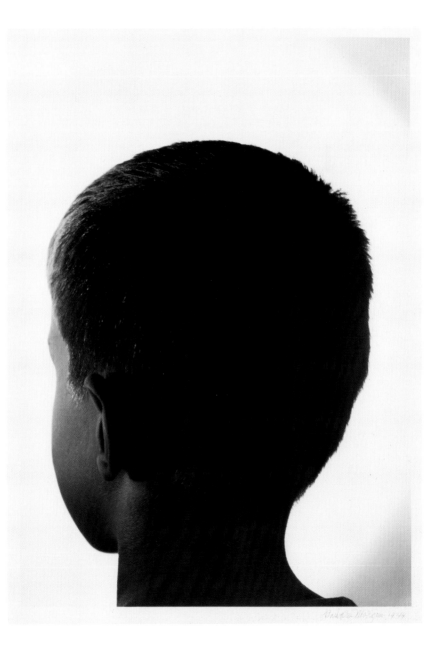

[103]
R A L P H B A R T H O L O M E W
Playtex Advertisement
1948
Vintage Gelatin Silver Print
7 1/2 x 9 1/2 inches (19 x 24,1 cm)

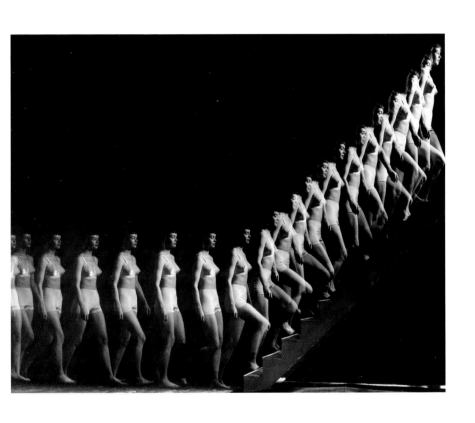

[104]
E Z R A S T O L L E R
Johnson House, New Canaan, Connecticut
1949
Vintage Gelatin Silver Print
10 5/8 x 13 1/2 inches (27 x 34,3 cm)

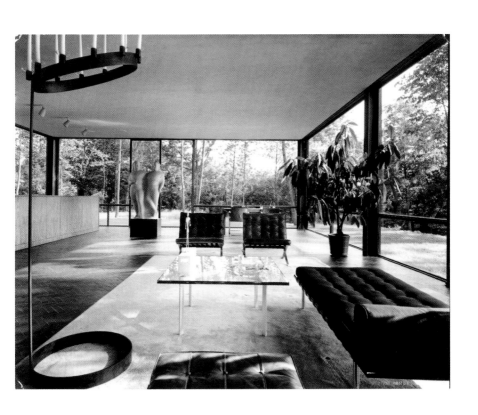

[105]
A R N O L D N E W M A N
Jackson Pollock
1949
Vintage Gelatin Silver Print
8 1/2 x 7 7/8 inches (21,6 x 20 cm)

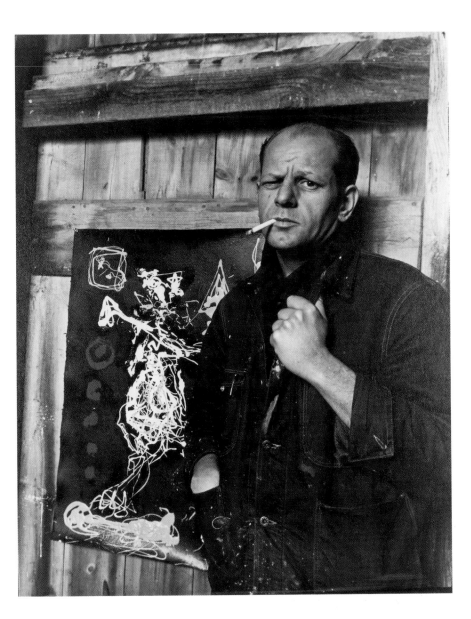

[106]
M A R V I N E . N E W M A N
Halloween, South Side
1951
Gelatin Silver Print
8 x 10 inches (20,3 x 25,4 cm)

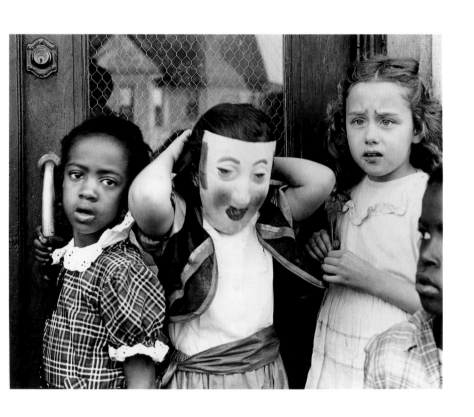

[107]
MARVIN E. NEWMAN
Untitled, Chicago
1951
Vintage Gelatin Silver Print
9 x 7 1/2 inches (22,9 x 19 cm)

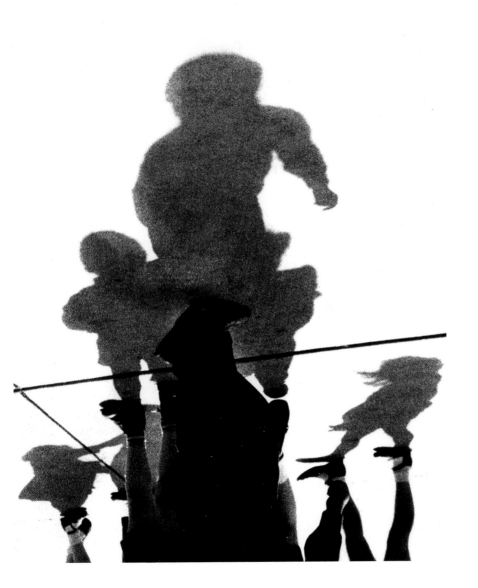

[108]
H A R R Y C A L L A H A N
Chicago
1950
Gelatin Silver Print
8 7/16 x 12 1/2 inches (21,4 x 31,7 cm)

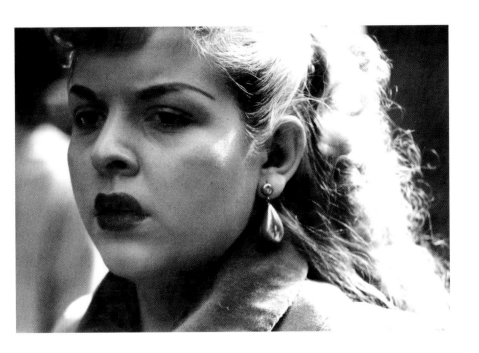

M A X Y A V N O
Muscle Beach
1949
Four Vintage Gelatin Silver Prints
7 7/16 x 9 1/2 to 5 1/8 x 8 5/8 inches (18,9 x 24,1 cm à 13 x 21,9 cm)

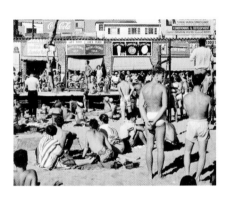
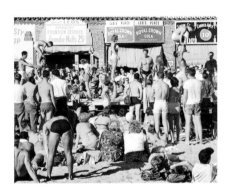
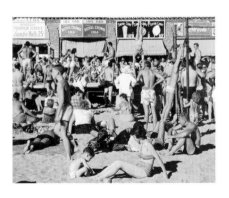
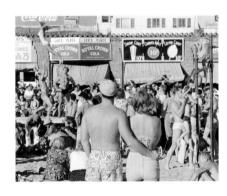

[110]
T E D C R O N E R
Central Park South
1948
Gelatin Silver Print
15 1/4 x 18 7/8 inches (38,7 x 47,9 cm)

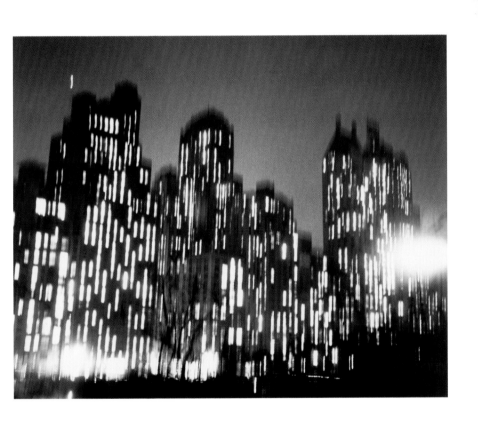

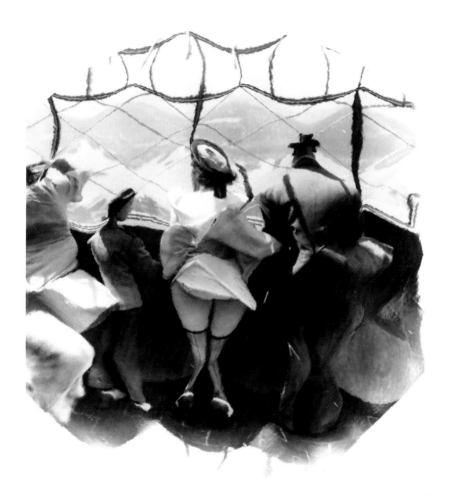

[112]
R I C H A R D A V E D O N
Charles Chaplin Leaving America, New York City
September 13, 1952
Gelatin Silver Print
10 13/16 x 13 3/4 inches (27,5 x 34,9 cm)

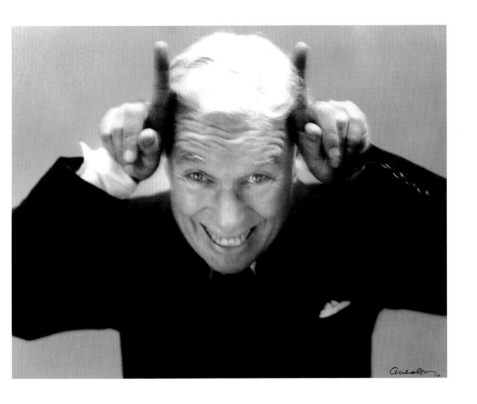

[113]
R O Y D E C A R A V A
Woman Descending Stairs
1951
Gelatin Silver Print
11 x 14 inches (27,9 x 35,6 cm)

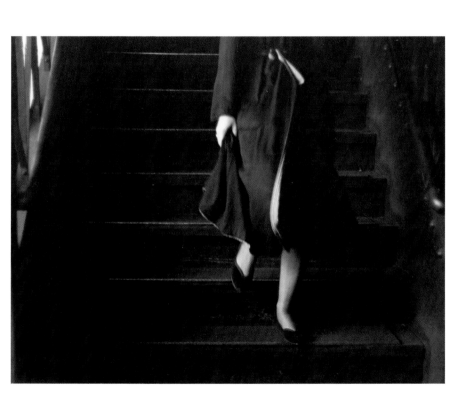

[114]
F R A N K P O W O L N Y
Marilyn Monroe
1952
Vintage Gelatin Silver Print
9 1/2 x 7 5/8 inches (24,1 x 19,4 cm)

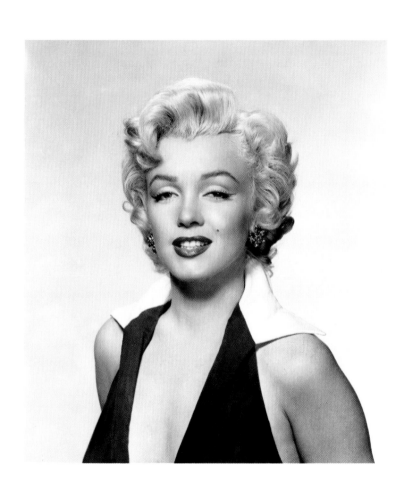

[115]
P A U L S T R A N D
The Family, Italy
1953
Gelatin Silver Print
11 7/16 x 14 5/8 inches (29 x 37,1 cm)

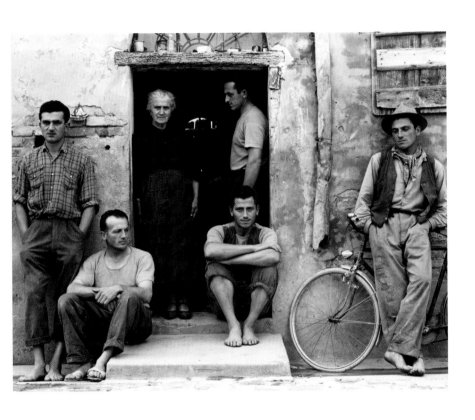

[116]
BRETT WESTON
Garapata Beach
1954
Vintage Gelatin Silver Print
7 9/16 x 9 1/2 inches (19,2 x 24,1 cm)

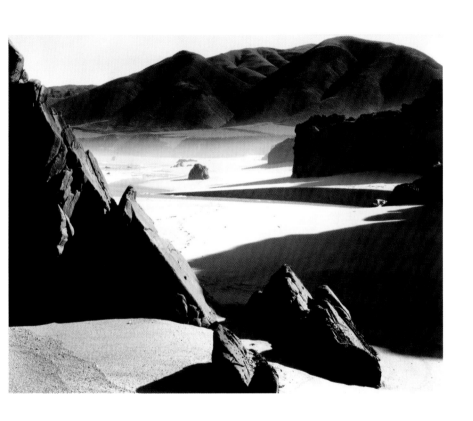

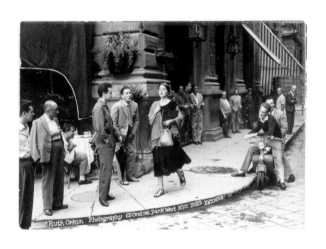

Ruth Orkin Photography 65 Central Park West NYC 10023 EN22658

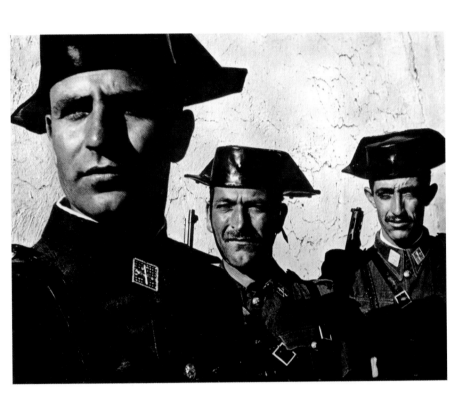

[119]
O . W I N S T O N L I N K

Stopping at Creek Junction to take on water, the southbound Virginia Creeper's Engine 382 lifts its safety valve. Engineer Joe McNew and brakeman J.M. "Skutch" Stevens pose for the camera on the bank of White Top Laurel Creek.

October, 1956
Chromogenic Dye Coupler Print
14 x 18 inches (35,6 x 45,7 cm)

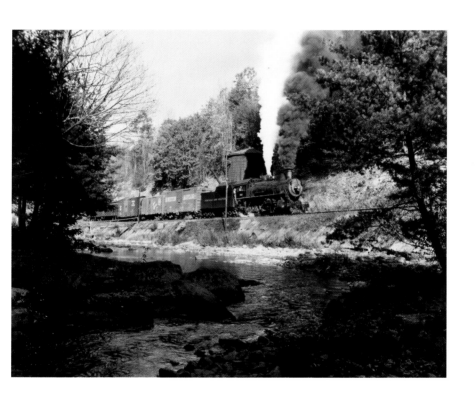

[120]
LEON LEVINSTEIN
Coney Island
1957
Vintage Gelatin Silver Print
10 3/8 x 13 9/16 inches (26,3 x 34,4 cm)

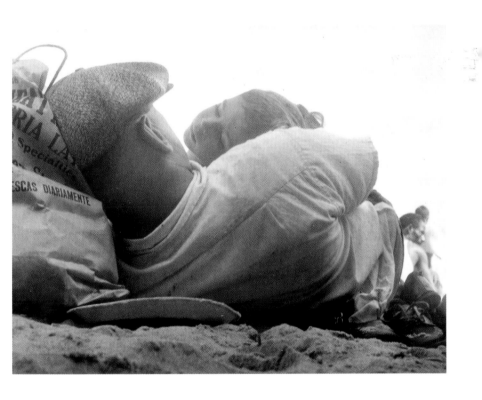

[121]
A N D R É K E R T É S Z
Washington Square Park
1954
Vintage Gelatin Silver Print
5 x 3 3/4 inches (12,7 x 9,5 cm)

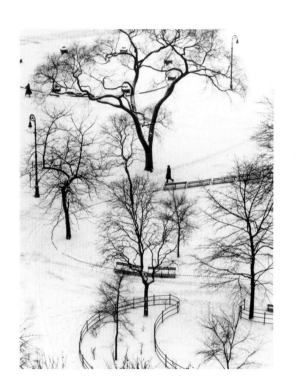

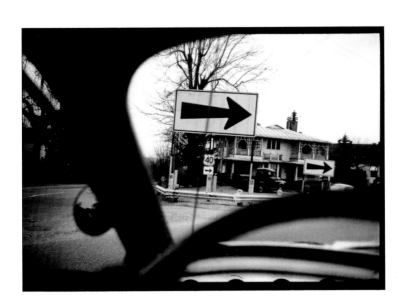

[123]
L A R R Y C O L W E L L
Untitled
c. 1956
Vintage Gelatin Silver Print
10 x 8 inches (25,4 x 20,3 cm)

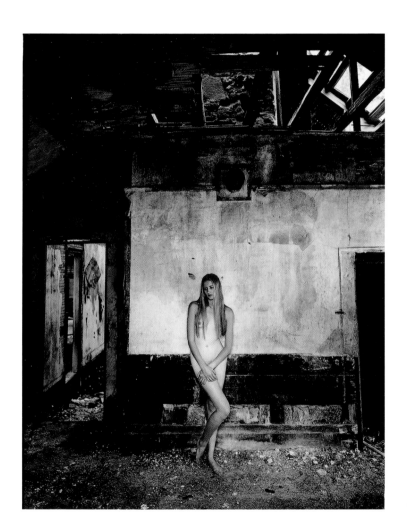

[124]
A A R O N S I S K I N D
From *Pleasures and Terrors of Levitation*
1960 (top) ; 1954 (bottom)
Vintage Gelatin Silver Prints
9 3/8 x 9 3/4 inches and 10 3/16 x 10 3/16 inches (23,8 x 24,8 cm et 25,9 x 25,9 cm)

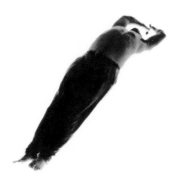
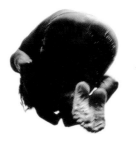

[125]
W Y N N B U L L O C K
Nude in Forest
c. 1950
Vintage Gelatin Silver Print
8 x 10 inches (20,3 x 25,4 cm)

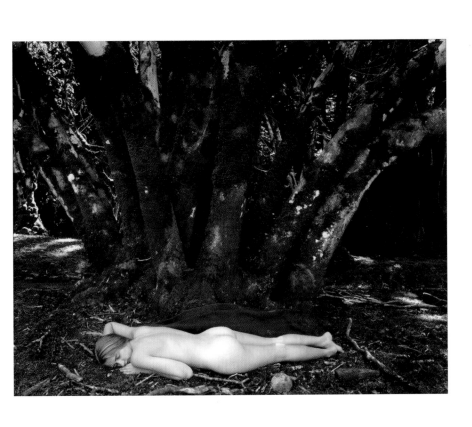

DENNIS STOCK
James Dean
1955
Gelatin Silver Print
24 x 20 inches (61 x 50,8 cm)

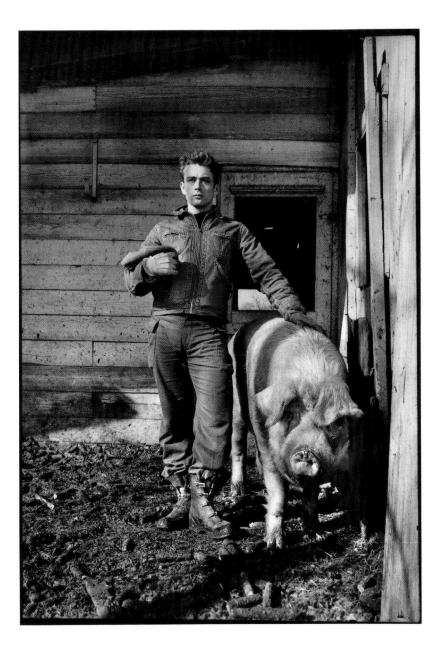

[127]
WILLIAM KLEIN
Broadway
1954
Vintage Gelatin Silver Print
11 3/4 x 8 1/2 inches (29,8 x 21,6 cm)

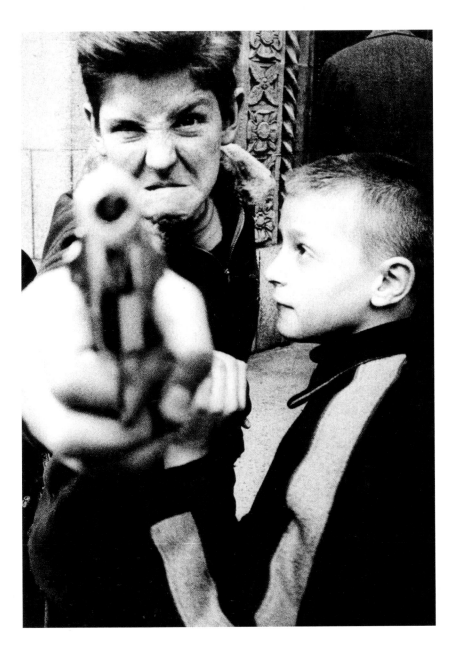

[128]
G O R D O N P A R K S
Emerging Man
1952
Gelatin Silver Print
8 13/16 x 13 inches (22,4 x 33 cm)

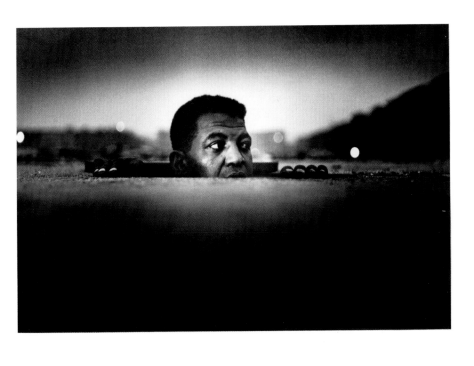

[129]
R I C H A R D A V E D O N
Dovima with Elephants, Evening Dress by Dior, Cirque d'Hiver
1955
Vintage Gelatin Silver Print
24 x 20 inches (61 x 50,8 cm)

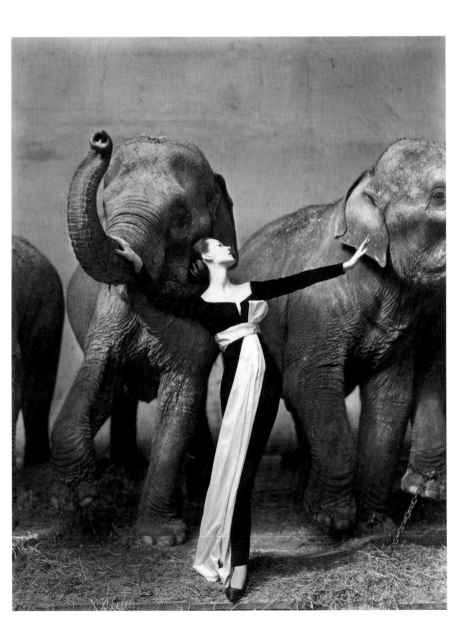

[130]
R O Y D E C A R A V A
Haynes, Jones and Benjamin
1956
Gelatin Silver Print
11 x 14 inches (27,9 x 35,6 cm)

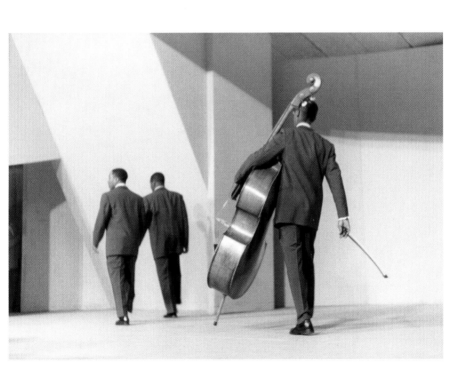

[131]
Y A S U H I R O I S H I M O T O
Chicago
c. 1956
Vintage Gelatin Silver Print
9 3/8 x 6 5/8 inches (23,8 x 16,8 cm)

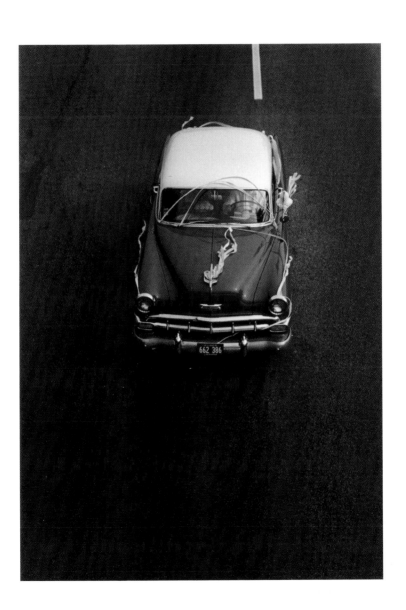

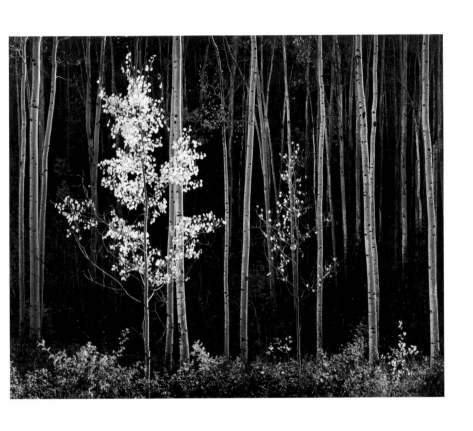

[133]
L O U S T E T T N E R
Penn Station
c. 1958
Vintage Gelatin Silver Print
8 3/4 x 13 1/2 inches (22,2 x 34,3 cm)

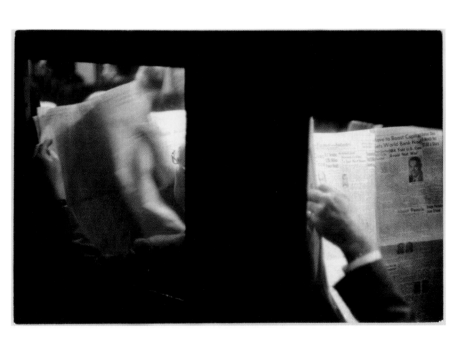

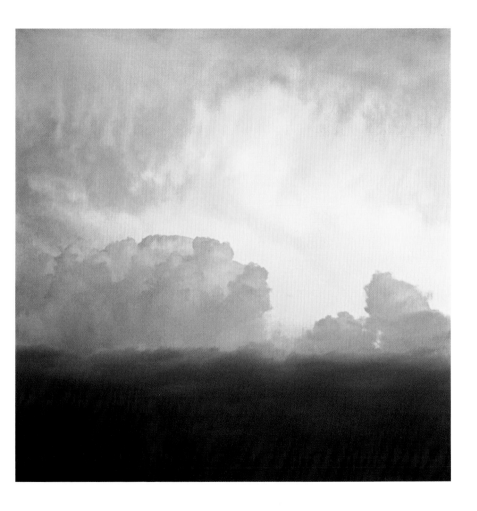

[135]
R A Y K . M E T Z K E R
Chicago
1959
Gelatin Silver Print
14 x 11 inches (35,6 x 27,9 cm)

[136]
A A R O N S I S K I N D
San Luis Potosi, Mexico #19
1961
Vintage Gelatin Silver Print
10 3/8 x 13 7/16 inches (26,3 x 34,1 cm)

R A L P H E U G E N E M E A T Y A R D
Untitled
1957
Vintage Gelatin Silver Print
9 x 12 inches (22,9 x 30,5 cm)

[138]
R O B E R T R I G E R
Johnny Unitas, Baltimore Colts quarterback, passes against New
York Giant defense, Championship Game, Yankee Stadium, New York
1958
Unique Signed Platinum Print
12 x 16 inches (30,5 x 40,6 cm)

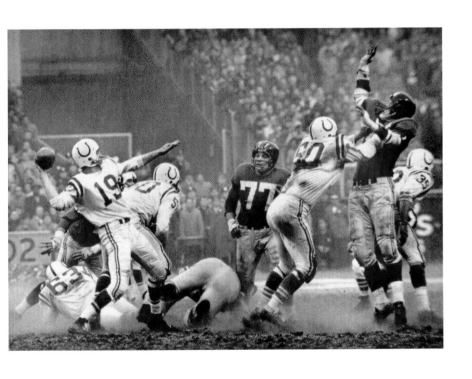

[139]
A N D R É K E R T É S Z
Still Life With Snake
1960
Vintage Gelatin Silver Print
9 3/4 x 7 3/4 inches (24,8 x 19,7 cm)

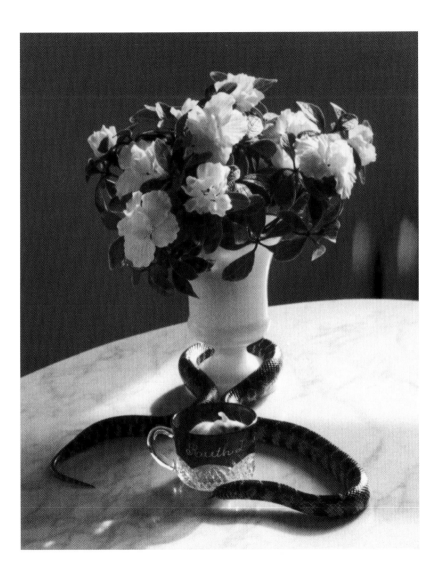

[140]
LILLIAN BASSMAN
The Diver
1959
Vintage Gelatin Silver Print
12 x 9 11/16 inches (30,5 x 24,6 cm)

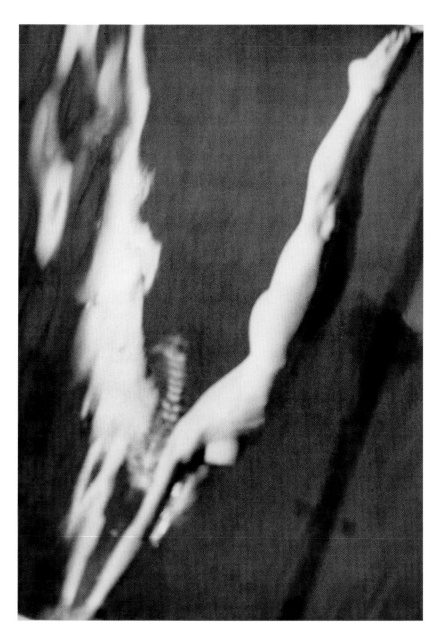

P E T E R H U J A R
Untitled, Southbury, Connecticut
1957
Vintage Gelatin Silver Print
15 x 15 inches (38,1 x 38,1 cm)

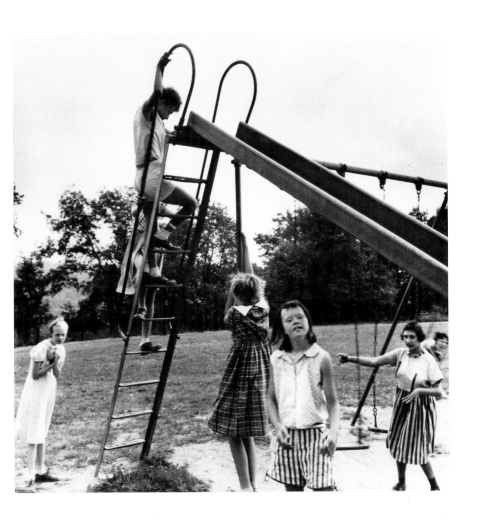

[142]
CORNELL CAPA
John F. Kennedy, First Cabinet Meeting
1961
Vintage Gelatin Silver Print
13 1/2 x 10 3/4 inches (34,3 x 27,3 cm)

[143]
O R M O N D G I G L I
Models in Window
1960
Vintage Dye Transfer Print
16 x 16 inches (40,6 x 40,6 cm)

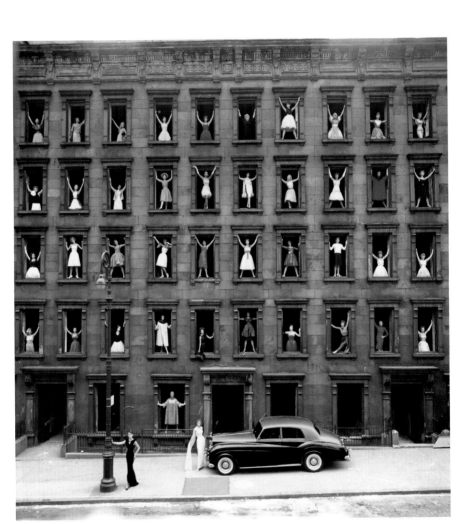

P E T E R B E A R D

P.B. 1962 at John Palmer's 1750 Vermont House during Hallalujah the Hills
1962
Gelatin Silver Print
8 1/2 x 25 1/2 inches (21,6 x 64,8 cm)

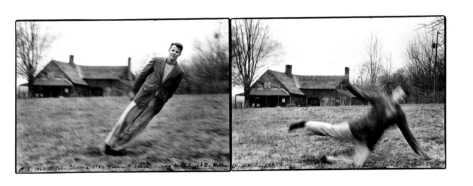

[145]
MINOR WHITE
Moon, Wall, Encrustations, Pultneyville, New York
1964
Vintage Gelatin Silver Print
9 x 12 3/8 inches (22,9 x 31,4 cm)

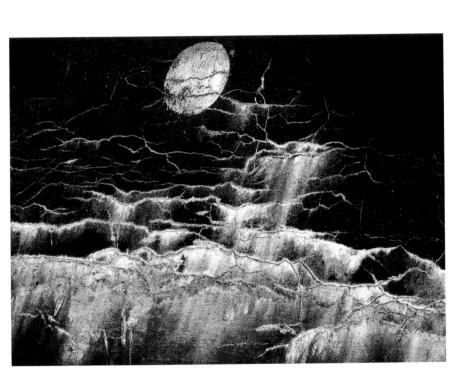

[146]
D I A N E A R B U S
Circus fat lady and her dog, Troubles
1964
Vintage Gelatin Silver Print
8 x 7 1/2 inches (20,3 x 19 cm)

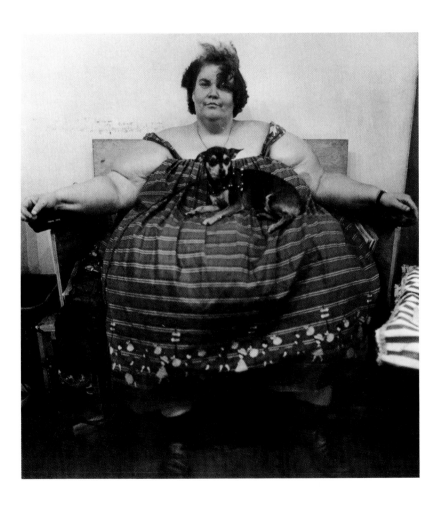

[147]
C H A R L E S M O O R E
Demonstrators Blasted Against Doorway, Seventeenth Street,
Birmingham, Alabama
May 3, 1963
Vintage Gelatin Silver Print
6 1/2 x 10 inches (16,5 x 25,4 cm)

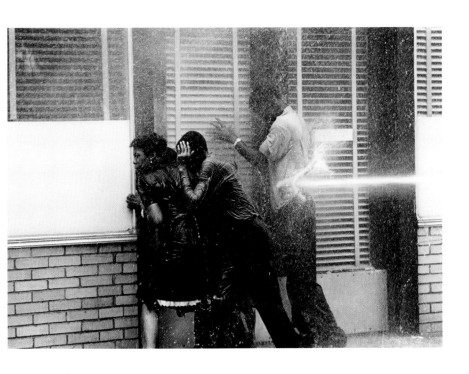

[148]
I R V I N G P E N N
Saul Steinberg in Paper Mask, New York
1966
Platinum Print
24 7/8 x 21 inches (63,2 x 53,3 cm)

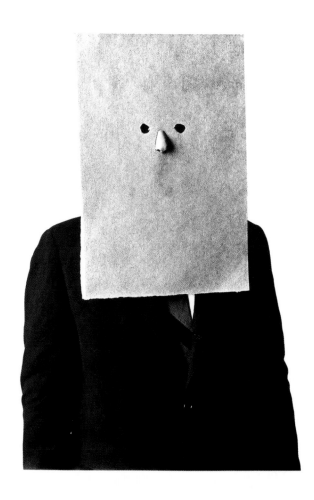

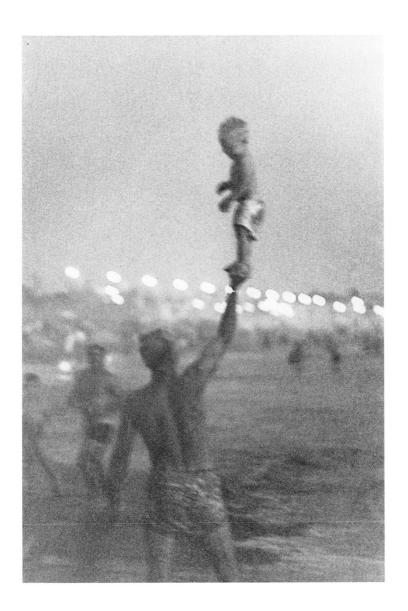

[150]
BRUCE DAVIDSON
A Trip West
1965
Gelatin Silver Print
16 x 20 inches (40,6 x 50,8 cm)

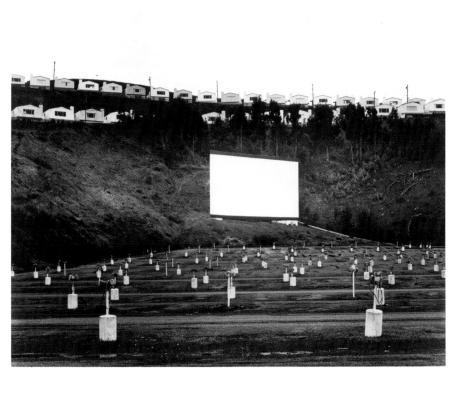

[151]
F L I P S C H U L K E
Mrs. Gordon Cooper Watching Her Husband Pass Overhead In Gemini 1
Space Craft
1965
Vintage Gelatin Silver Print
13 1/2 x 9 inches (34,3 x 22,9 cm)

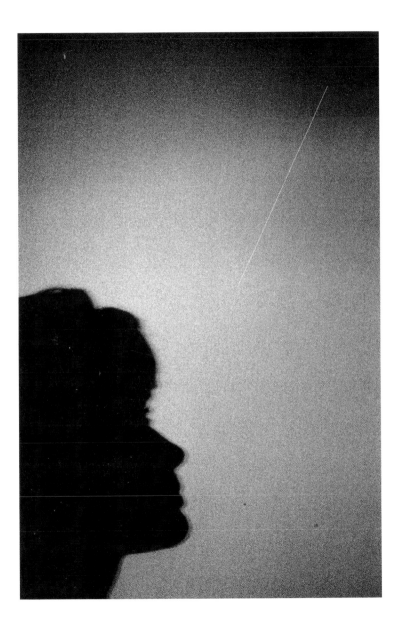

[152]
G A R R Y W I N O G R A N D
Central Park Zoo
1967
Vintage Gelatin Silver Print
8 3/4 x 13 inches (22,2 x 33 cm)

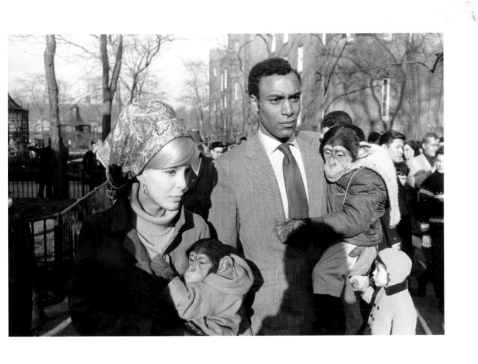

[153]
J O E L M E Y E R O W I T Z
Chartres
1966
Vintage Gelatin Silver Print
8 3/4 x 12 7/8 inches (22,2 x 32,7 cm)

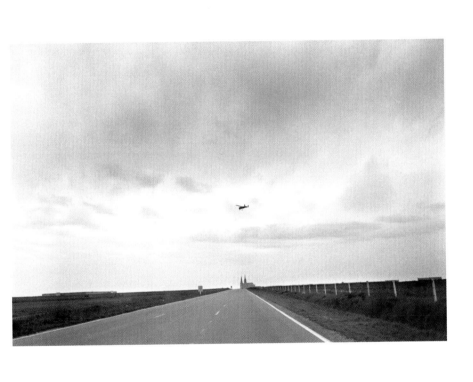

[154]
R A Y K . M E T Z K E R
Atlantic City
1966
Vintage Gelatin Silver Print
6 x 5 7/8 inches (15,2 x 14,9 cm)

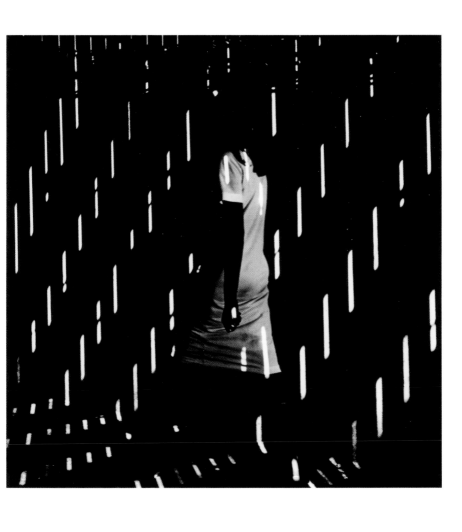

[155]
L E E F R I E D L A N D E R
New York City
1965
Vintage Gelatin Silver Print
7 x 11 inches (17,8 x 27,9 cm)

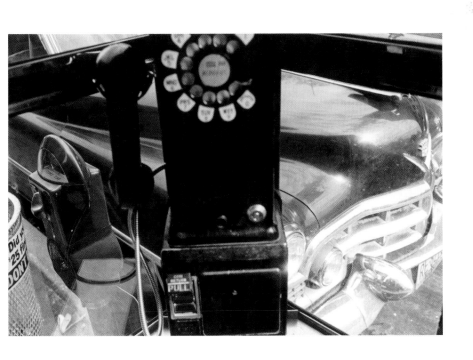

J O H N L O E N G A R D
Ad Reinhardt Hanging Paintings in his Studio, New York City
1966
Vintage Gelatin Silver Print
9 x 13 7/16 inches (22,9 x 34,1 cm)

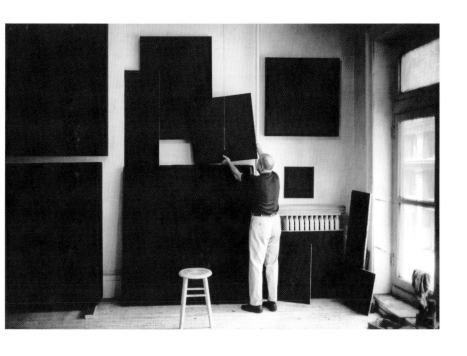

[157]
N A S A
LRC Lunar Orbiter Project–Mission III
February 8, 1967
Vintage Gelatin Silver Print
18 7/8 x 17 inches (47,9 x 43,2 cm)

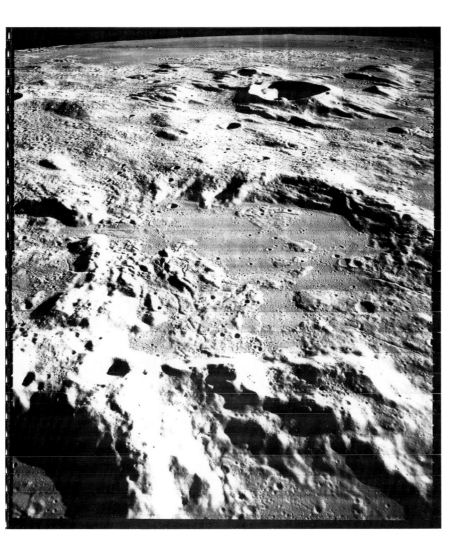

[158]
D A N N Y L Y O N
Crossing the Ohio
1966
Gelatin Silver Print
8 7/8 x 13 1/8 inches (22,5 x 33,3 cm)

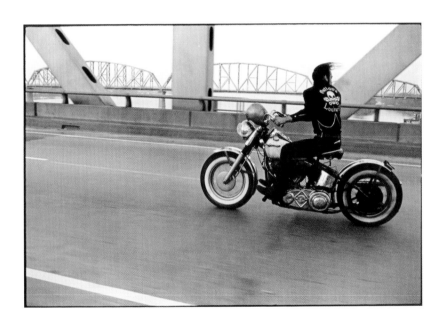

[159]
D E N N I S S T O C K
Venice Beach Rock Festival
1968
Gelatin Silver Print
24 x 20 inches (61 x 50,8 cm)

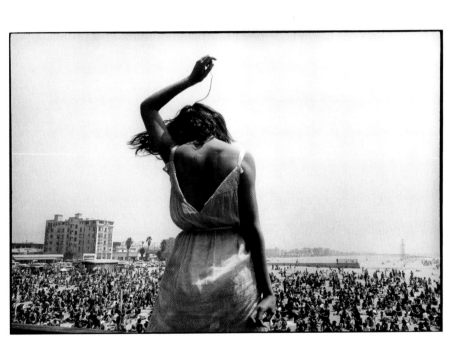

[160]
B R U C E D A V I D S O N
East 100th Street
1966-1968
Vintage Gelatin Silver Print
14 x 11 inches (35,6 x 27,9 cm)

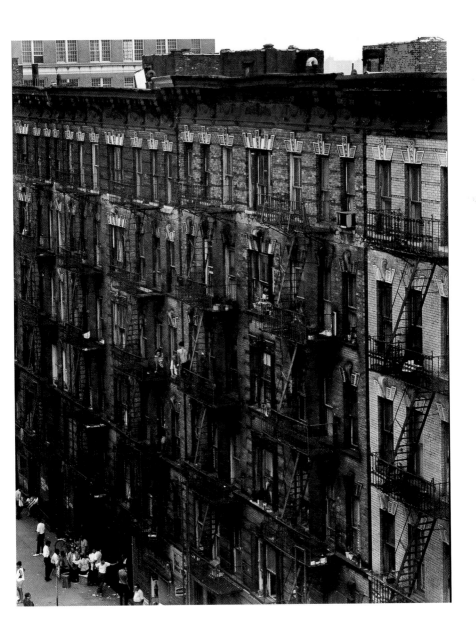

[161]
D A N N Y L Y O N
Untitled (Prisoner being patted down)
1968
Vintage Gelatin Silver Print
8 1/4 x 12 1/4 inches (21 x 31,1 cm)

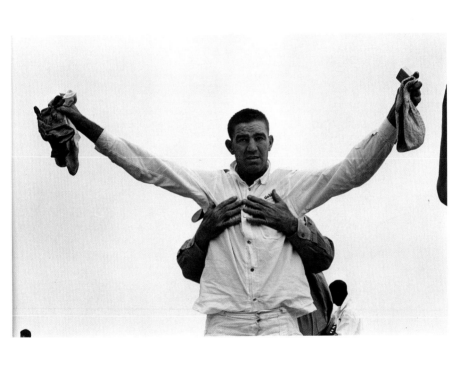

[162]
W I L L I A M E G G L E S T O N
Summer Mississippi, Cassidy Bayou in Background
1971
Dye Transfer Print
20 x 24 inches (50,8 x 61 cm)

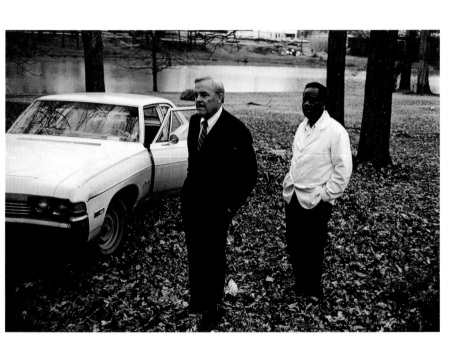

[163]
E M M E T G O W I N
Nancy and Dwayne, Danville, Virginia
1970
Vintage Gelatin Silver Print
6 1/3 x 6 3/8 inches (16,1 x 16,5 cm)

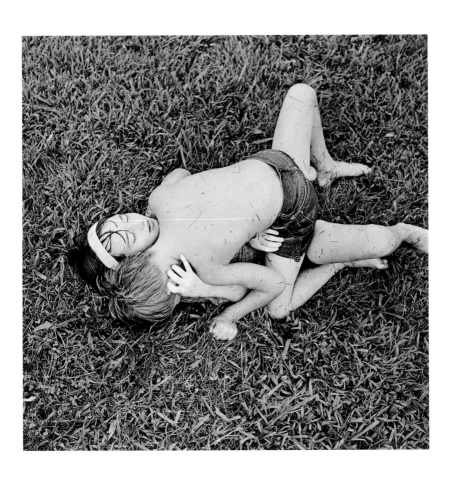

[164]
N E I L A R M S T R O N G / N A S A
*Edwin E. (Buzz) Aldrin with the deployed American Flag on the
Surface of the Moon*
July 20, 1969
Vintage Chromogenic Print
16 x 20 inches (40,6 x 50,8 cm)

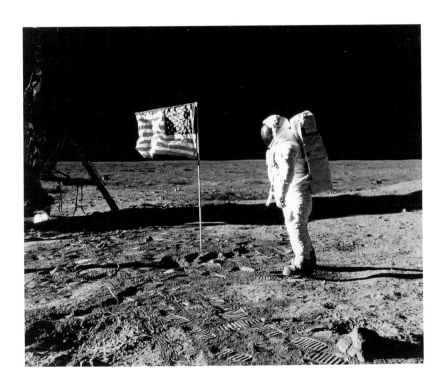

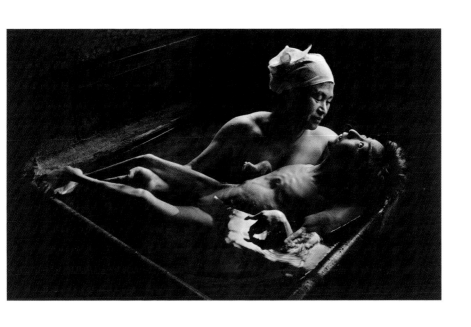

[166]
I R V I N G P E N N
Cigarette 37, New York
1972
Platinum Palladium Print
23 1/4 x 17 1/4 inches (59 x 43,8 cm)

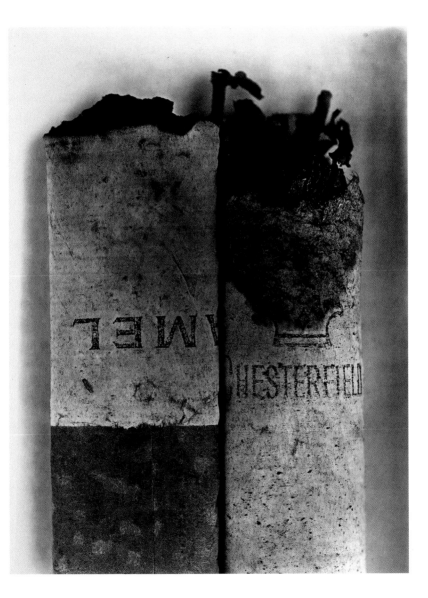

[167]
J E R R Y U E L S M A N N
Untitled
1972
Vintage Sepia-toned Gelatin Silver Print
10 x 8 inches (25,4 x 20,3 cm)

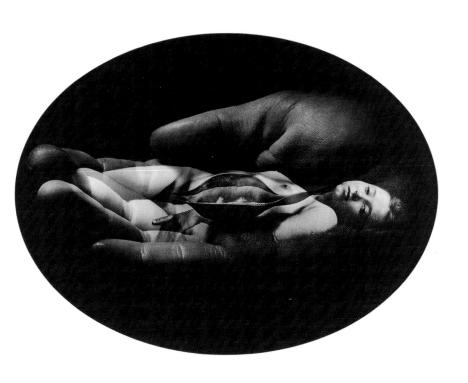

[168]
G E O R G E T I C E
Petit's Mobil Station, Cherry Hill, New Jersey
1974
Vintage Gelatin Silver Print
11 x 14 inches (27,9 x 35,6 cm)

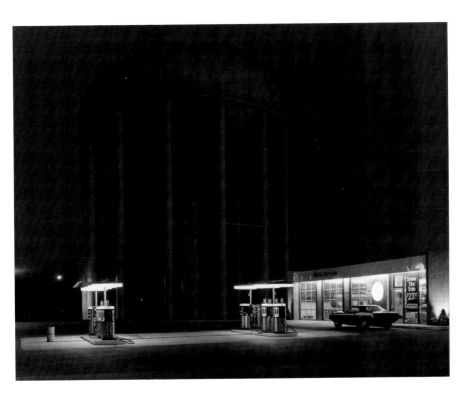

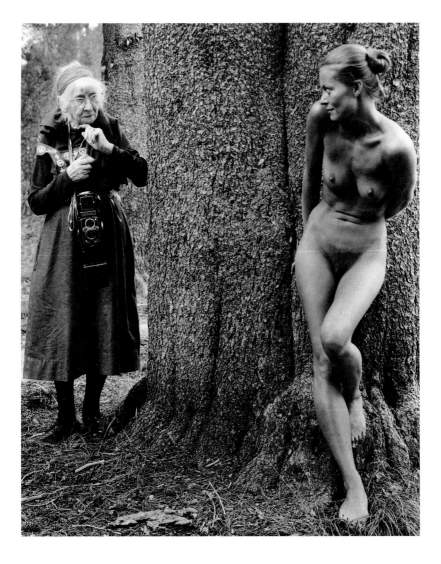

[170]
P A U L C A P O N I G R O
Kalamazoo, Michigan
c. 1975
Vintage Gelatin Silver Print
7 1/2 x 9 1/2 inches (19 x 24,1 cm)

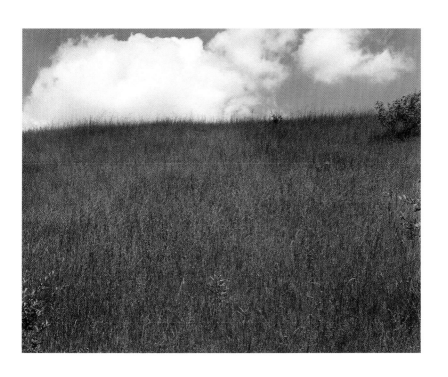

[171]
W A L K E R E V A N S
Untitled (King; Aton Nter; Must Go; Ice)
c. 1974
Four SX-70 Polaroids
3 1/8 x 3 1/16 inches (7,9 x 7,8 cm)

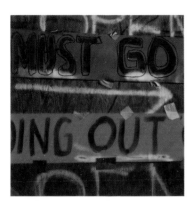

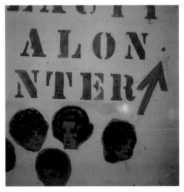

[172]
R I C H A R D A V E D O N
John Szarkowski
1975
Vintage Gelatin Silver Print
10 x 8 inches (25,4 x 20,3 cm)

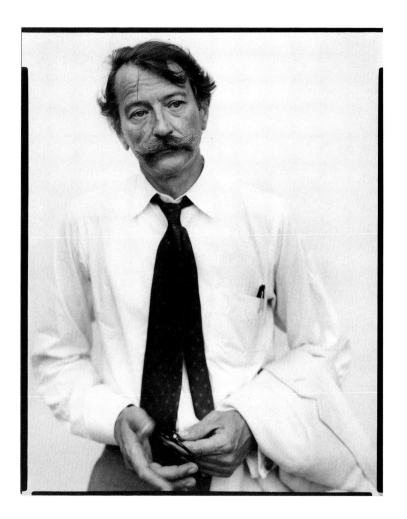

[173]
W I L L I A M G A R N E T T
Train Crossing Desert, Kelso, California
1975
Gelatin Silver Print
9 x 13 1/2 inches (22,9 x 34,3 cm)

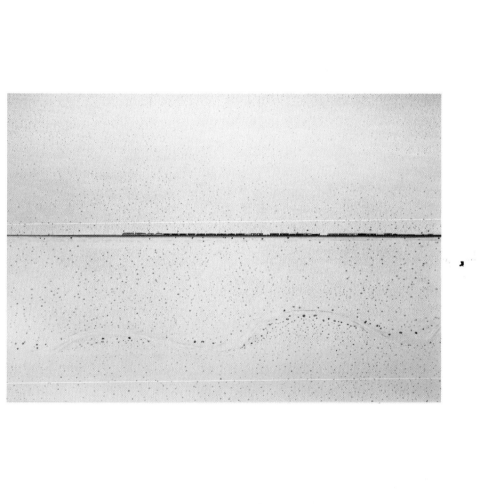

[174]
G A R R Y W I N O G R A N D
Fort Worth, Texas
1975
Gelatin Silver Print
11 x 14 inches (27,9 x 35,6 cm)

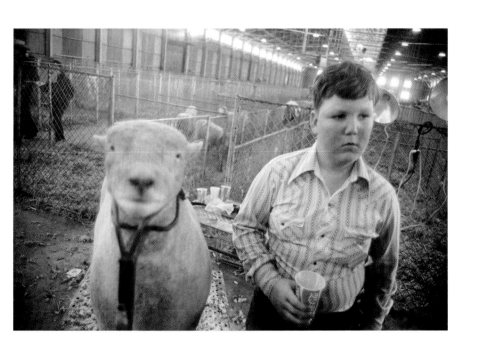

[175]
S U S A N M E I S E L A S
Carnival Strippers
1975
Vintage Gelatin Silver Print
10 x 8 inches (25,4 x 20,3 cm)

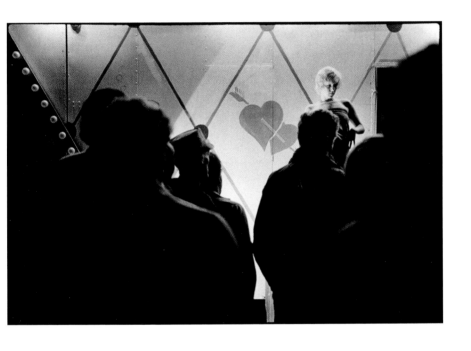

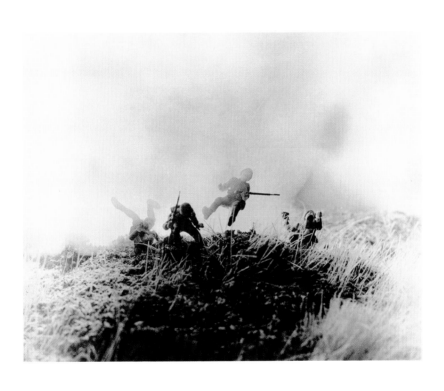

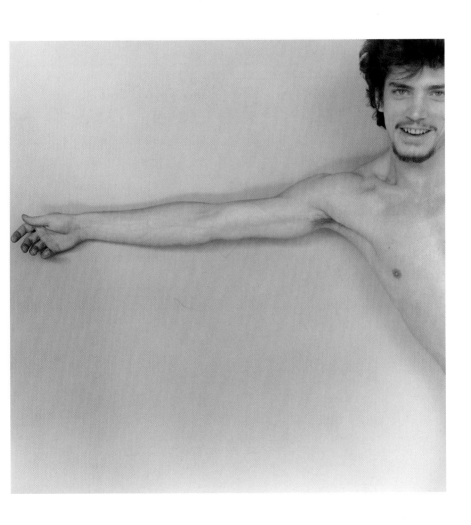

[178]
PRO ARTS INC.
Farah Fawcett
1976
Chromogenic Print
10 x 8 inches (25,4 x 20,3 cm)

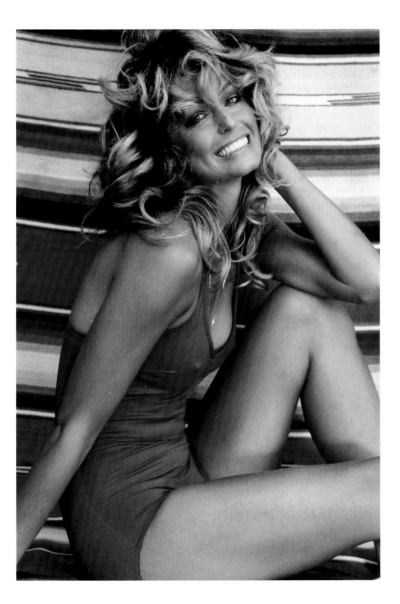

[179]
J O E L M E Y E R O W I T Z
Forty-sixth Street and Seventh Avenue
1976
Dye Transfer Print
20 x 24 inches (50,8 x 61 cm)

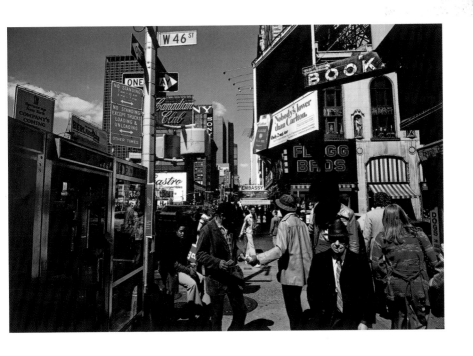

[180]
NICHOLAS NIXON
The Brown Sisters
1976
Vintage Gelatin Silver Print
8 x 10 inches (20,3 x 25,4 cm)

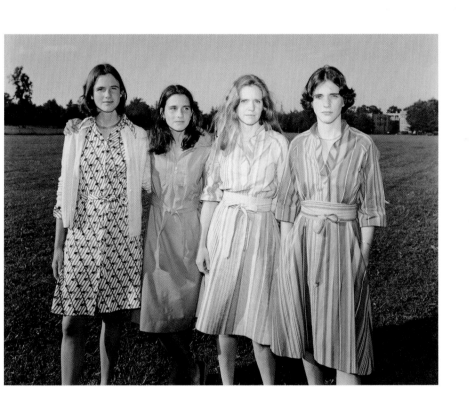

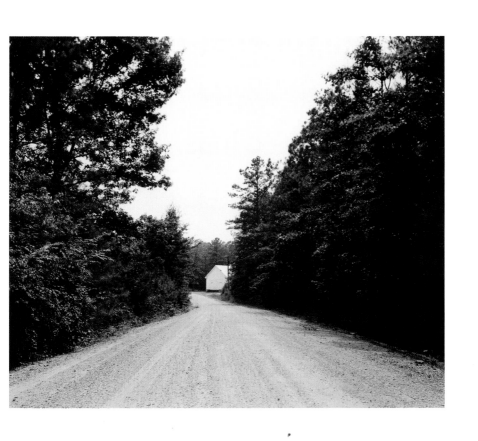

[182]
C I N D Y S H E R M A N
Untitled Film Still
1978
Gelatin Silver Print
10 x 8 inches (25,4 x 20,3 cm)

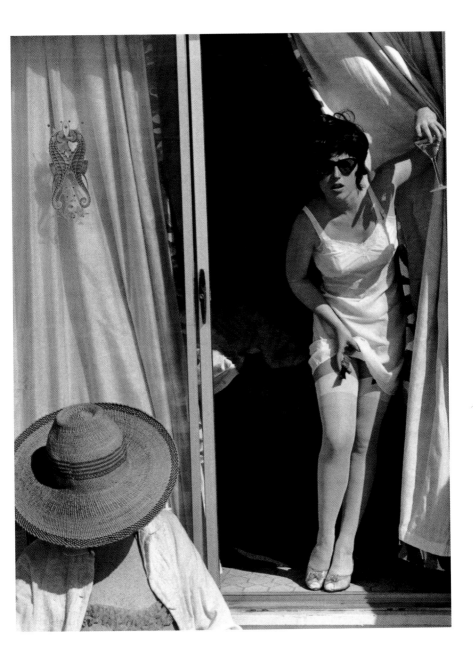

[183]
A N N I E L E I B O V I T Z
The Blues Brothers, Hollywood
1979
Cibachrome Print
14 1/4 x 14 1/4 inches (36,2 x 36,2 cm)

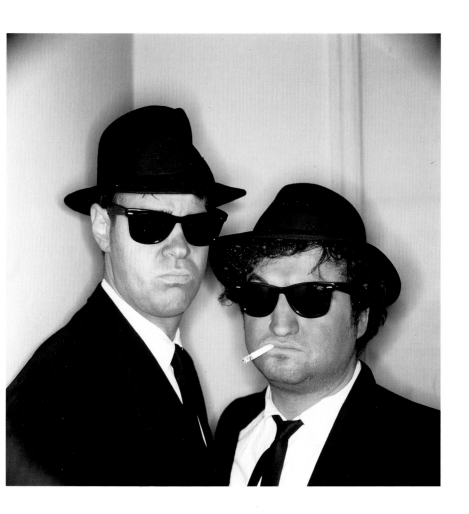

[184]
S H E I L A M E T Z N E R
Egypt Pyramids
1980
Fresson Print
13 x 19 1/4 inches (33 x 48,9 cm)

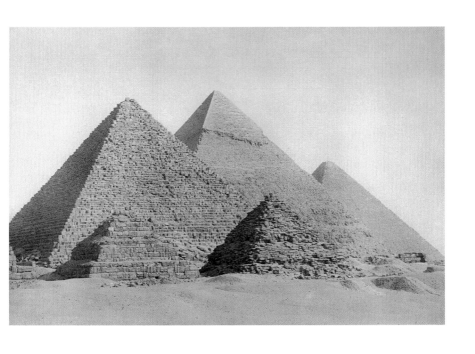

TIMOTHY GREENFIELD-SANDERS
Cindy Sherman
1980
Gelatin Silver Print
14 x 11 inches (35,6 x 27,9 cm)

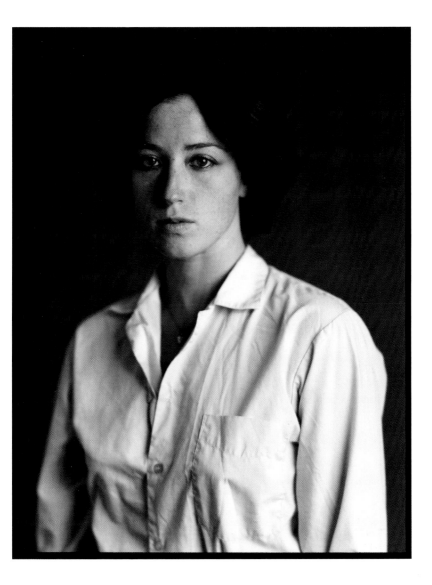

[186]
W I L L I A M W E G M A N
Lee Street Pond
1981
Ektacolor Prints
15 1/2 x 15 1/2 inches each (39,4 x 39,4 cm chacun)

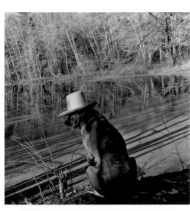

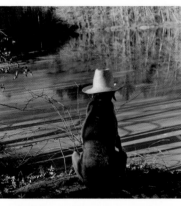

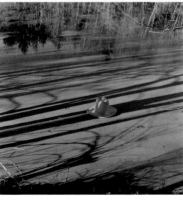

[187]
PHILIP-LORCA DI CORCIA
Catherine
1981
Ektacolor Print
15 1/4 x 22 15/16 inches (38,7 x 58,4 cm)

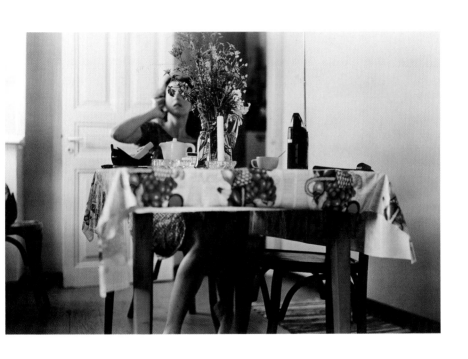

R O B E R T A D A M S
On Signal Hill, Overlooking Long Beach, California
1983
Vintage Gelatin Silver Print
14 x 11 inches (35,6 x 27,9 cm)

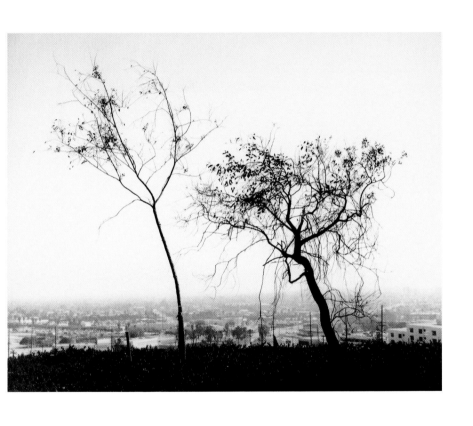

[189]
P E T E R H U J A R
Nude
1982
Vintage Gelatin Silver Print
14 1/2 x 14 1/2 inches (36,8 x 36,8 cm)

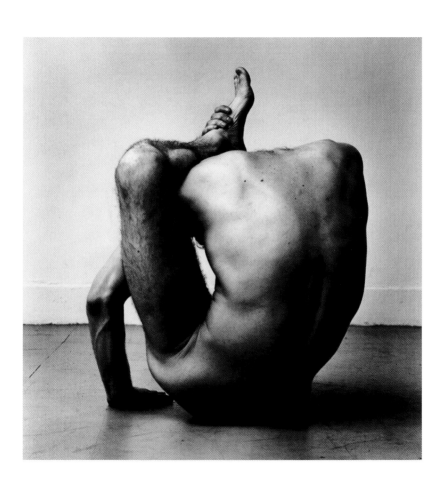

[190]
J A N G R O O V E R
Untitled
1982
Platinum Palladium Print
10 1/4 x 13 1/2 inches (26 x 34,3 cm)

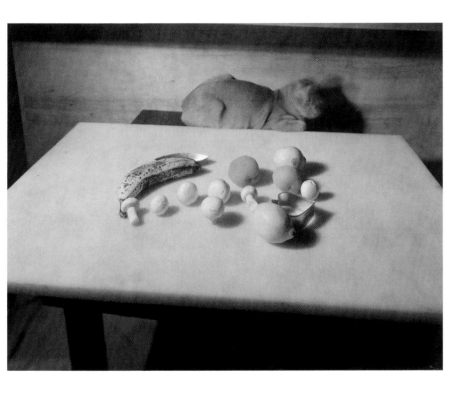

[191]
J O E L M E Y E R O W I T Z
Longnook Beach, Cape Cod
1983
Kodak Ektacolor Print xs
20 x 24 inches (50,8 x 61 cm)

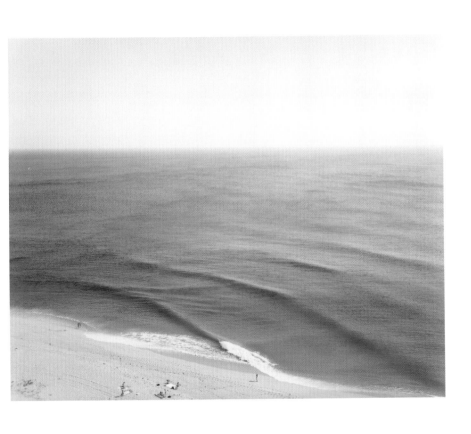

[192]
L E E F R I E D L A N D E R
Nude
1982
Gelatin Silver Print
20 x 16 inches (50,8 x 40,6 cm)

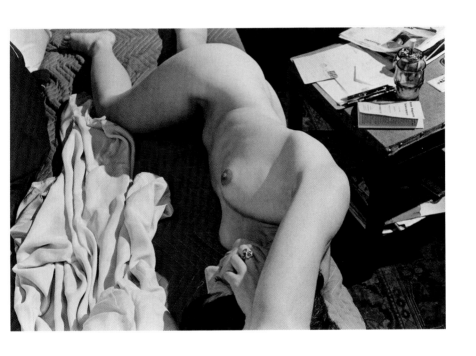

[193]
S A L L Y M A N N
Jessie Bites
1985
Gelatin Silver Print
20 x 16 inches (50,8 x 40,6 cm)

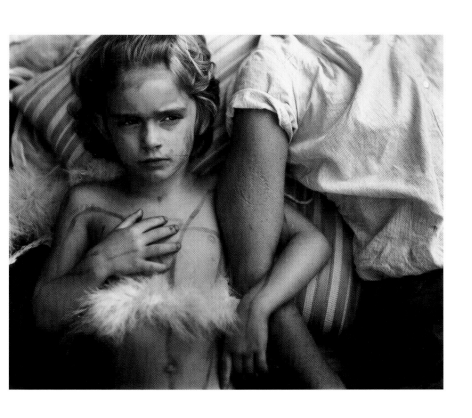

[194]
SALLY GALL
Amazon
1986
Gelatin Silver Print
15 x 15 inches (38,1 x 38,1 cm)

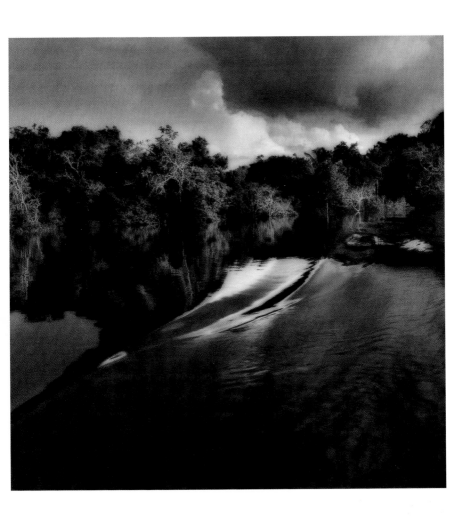

[195]
BRUCE WEBER
Jeff, Cross-Country Runner
1985
Vintage Gelatin Silver Print
14 x 11 inches (35,6 x 27,9 cm)

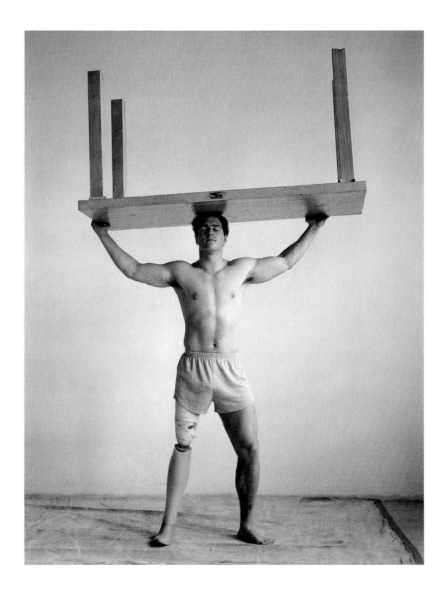

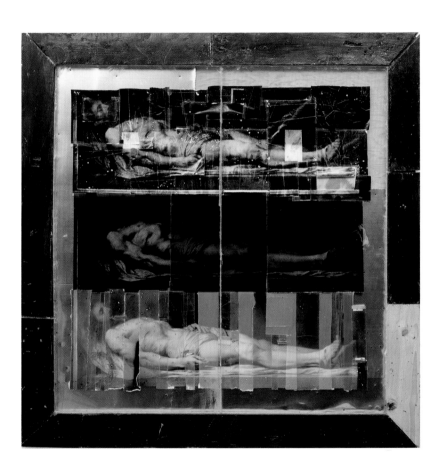

[197]
Z E K E B E R M A N
Untitled
1987
Gelatin Silver Print
19 x 15 inches (48,3 x 38,1 cm)

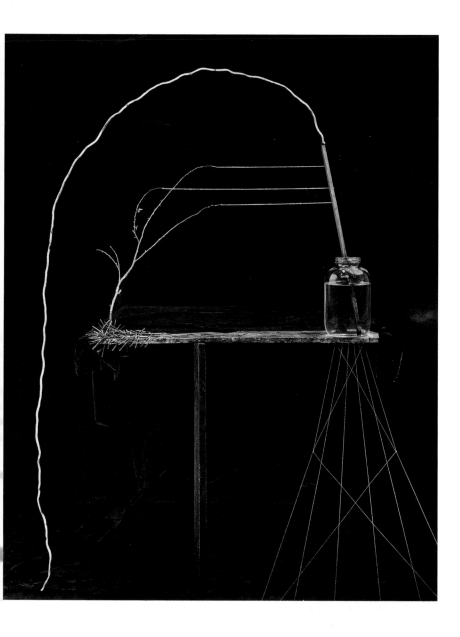

[198]
D O N N A F E R R A T O
8 year-old Diamond said "I hate you for hitting my mother. Don't you ever come back to this house," Minneapolis
1989
Gelatin Silver Print
9 x 13 inches (22,9 x 33 cm)

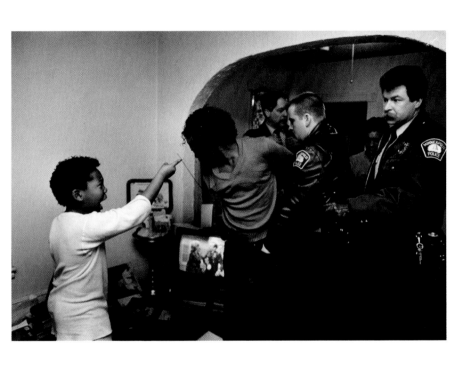

[199]
R O B E R T M A P P L E T H O R P E
American Flag
1977
Gelatin Silver Print
19 x 23 inches (48,3 x 58,4 cm)

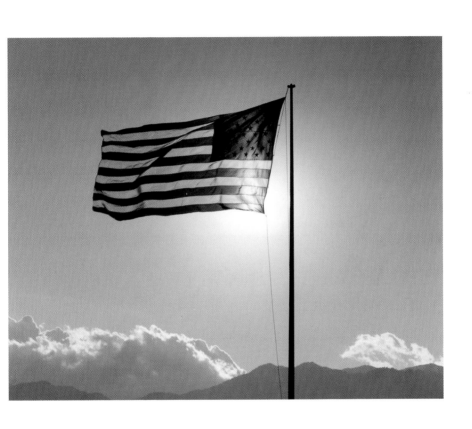

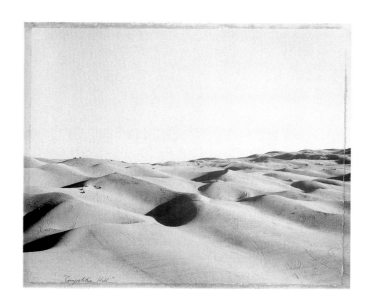

[200]
MARK KLETT
Competition Hill
1987
Gelatin Silver Print
16 x 20 inches each (40,6 x 50,8 cm chacun)

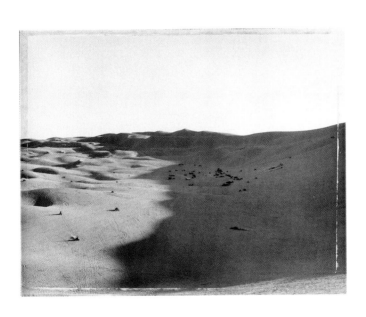

[201]
T I N A B A R N E Y
The Skier
1987
Chromogenic Color Print
30 x 40 inches (76,2 x 101,6 cm)

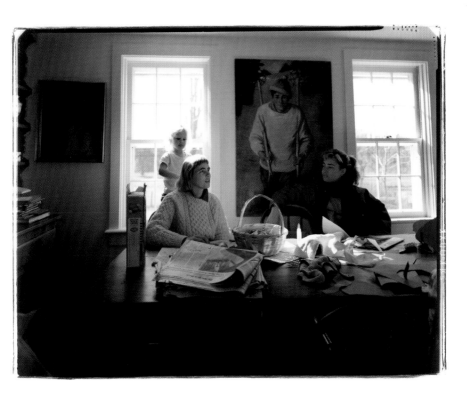

[202]
LYNN DAVIS
Iceberg, #20, Disko Bay, Greenland
1988
Gelatin Silver Print
28 x 28 inches (71,1 x 71,1 cm)

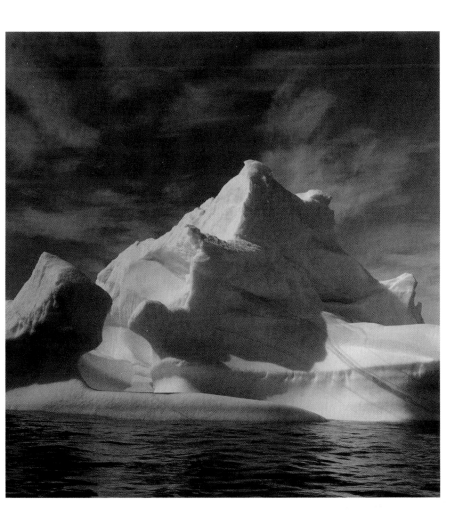

[203]
A N D R E A S S E R R A N O
Madonna and Child II
1989
Cibachrome Print
60 x 40 inches (152,4 x 101,6 cm)

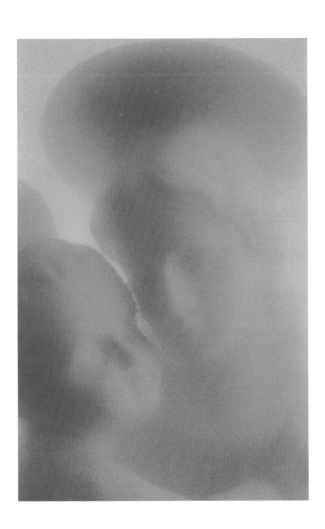

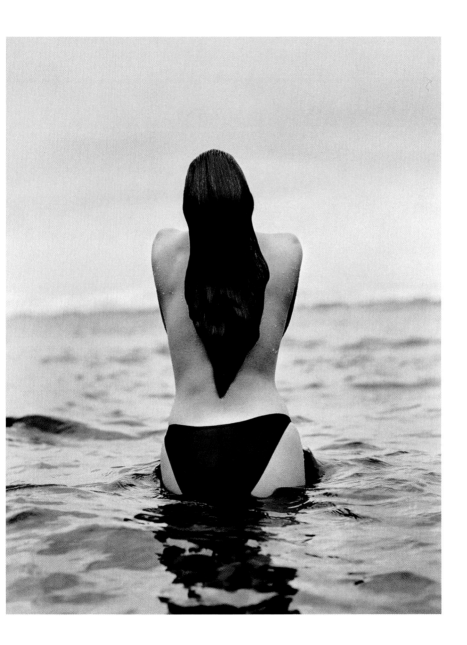

[206]
F R A N K S C H R A M M
McDonnell Douglas DC-10, JFK International Airport, New York
June 24, 1989
Gelatin Silver Print
19 x 19 inches (48,3 x 48,3 cm)

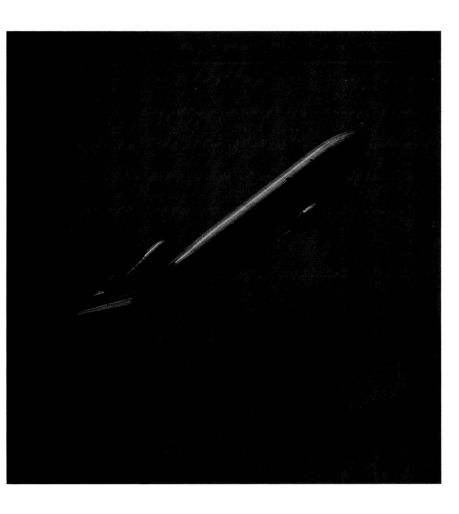

[207]
D A V I D W O J N A R O W I C Z
Untitled
1988
Vintage Gelatin Silver Print
30 x 40 inches (76,2 x 101,6 cm)

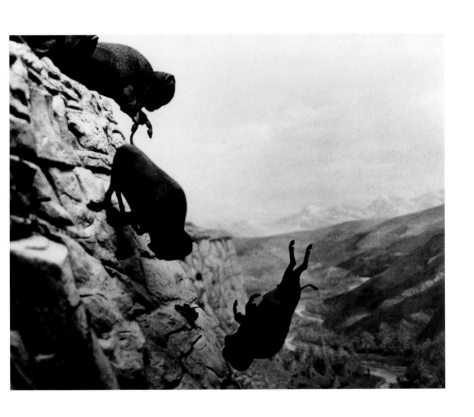

[208]
J U D I T H J O Y R O S S
Untitled, Easton Portraits
1988-1990
Printing-out Paper Print
9 1/2 x 7 1/2 inches (24,1 x 19 cm)

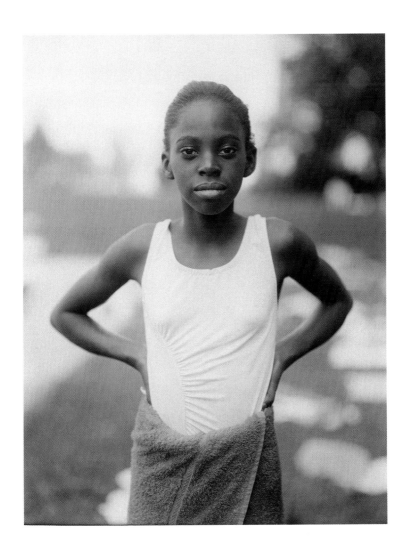

[209]
H I R O S H I S U G I M O T O
Compton Drive-In
1990
Gelatin Silver Print
20 x 24 inches (50,8 x 61 cm)

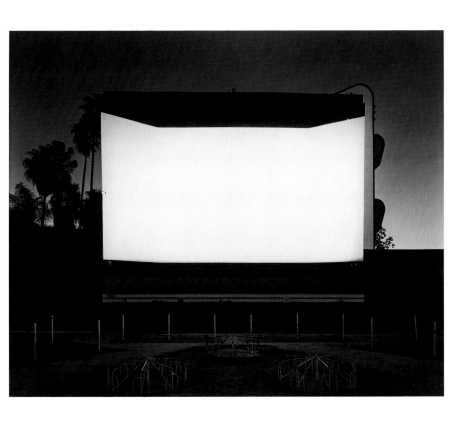

[210]
A D A M F U S S
Untitled
1990
Unique Cibachrome Photogram
20 x 24 inches (50,8 x 61 cm)

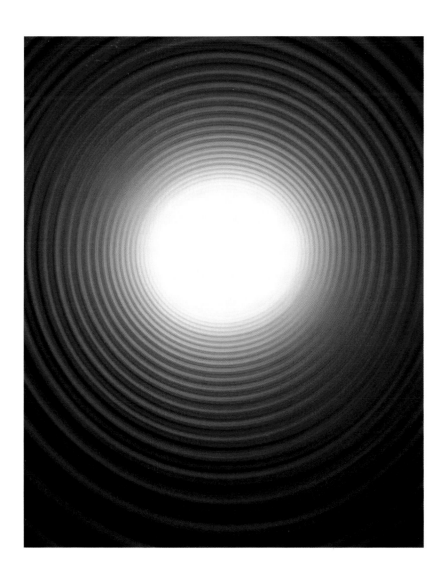

[211]
BILL JACOBSON
Interim Portrait, #245
1992
Gelatin Silver Print
14 x 11 inches (35,6 x 27,9 cm)

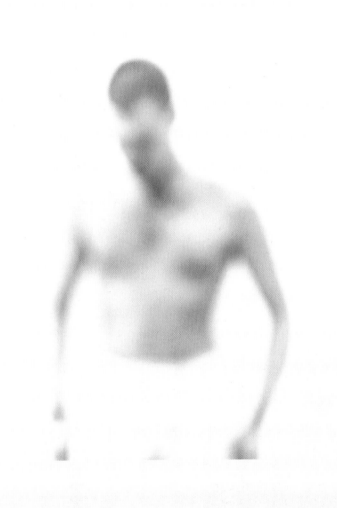

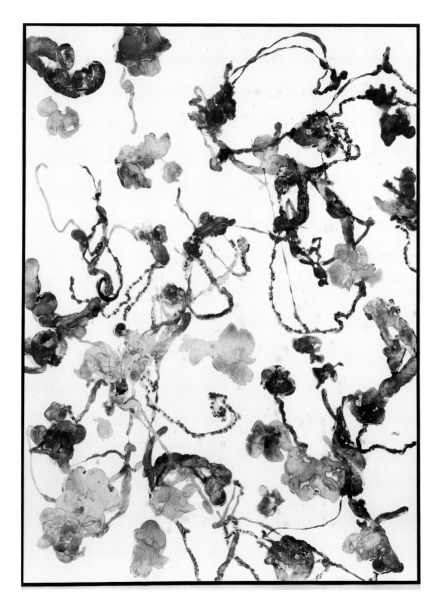

[213]
TOM BARIL
Brooklyn Bridge
1993
Toned Gelatin Silver Print
24 x 20 inches (61 x 50,8 cm)

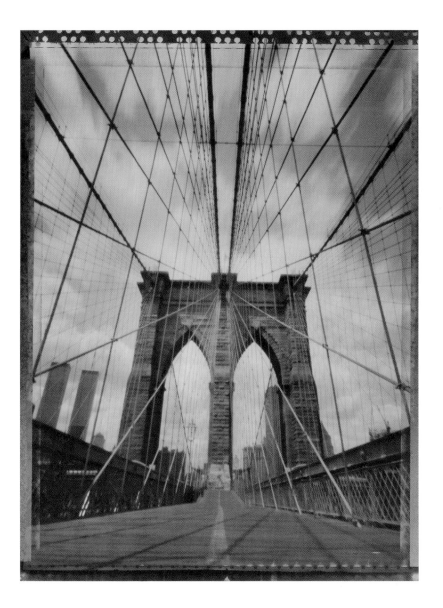

[214]
G R E G O R Y C R E W D S O N
Untitled
1992
Chromogenic Print
40 x 30 inches (101,6 x 76,2 cm)

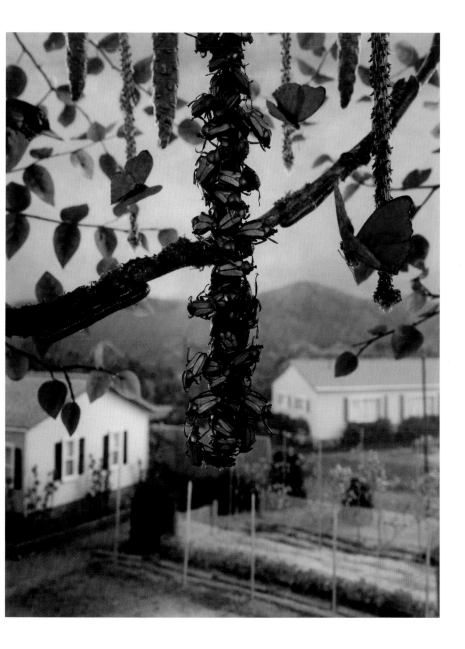

[215]
S A L L Y M A N N
Untitled
1993
Gelatin Silver Print
30 x 38 inches (76,2 x 96,5 cm)

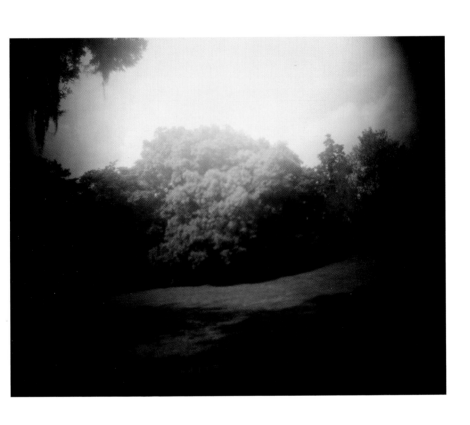

S T E P H E N B A R K E R
Night Swimming
1993
Vintage Gelatin Silver Print
20 x 24 inches (50,8 x 61 cm)

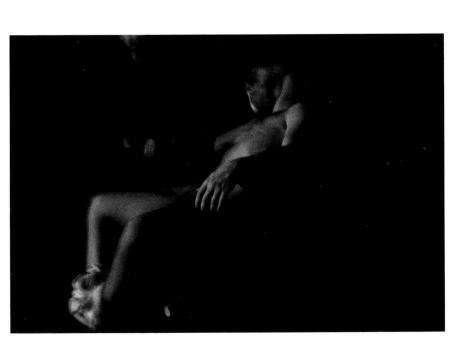

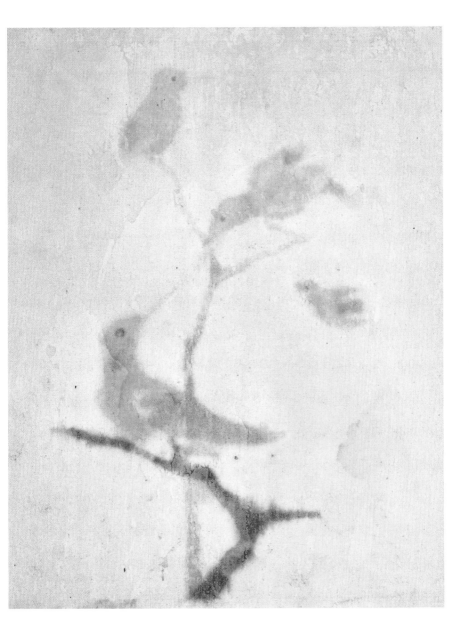

N A N G O L D I N
Amanda on my Fortuny, Berlin
1993
Cibachrome Print
30 x 40 inches (76,2 x 101,6 cm)

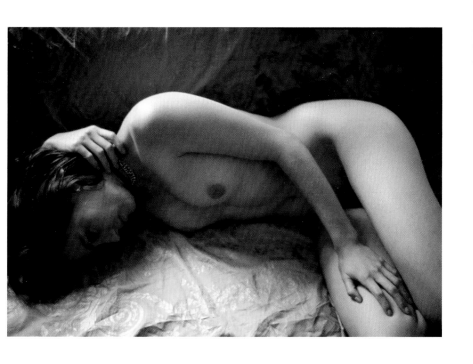

[219]
A B E L A R D O M O R E L L
Camera Obscura Image of the Sea in Attic
1994
Gelatin Silver Print
18 x 22 1/4 inches (45,7 x 56,5 cm)

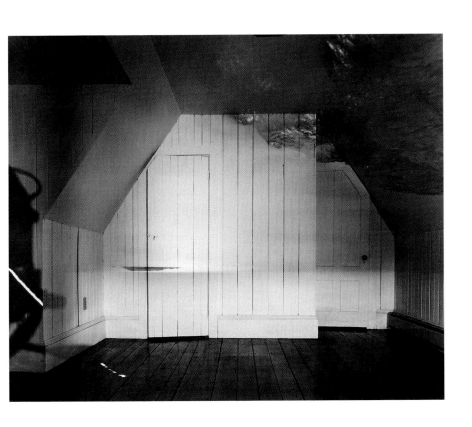

[220]
C H R I S T O P H E R G I G L I O
Untitled (Cathode Rayogram)
1994
Fujiflex Print
40 x 30 inches (101,6 x 76,2 cm)

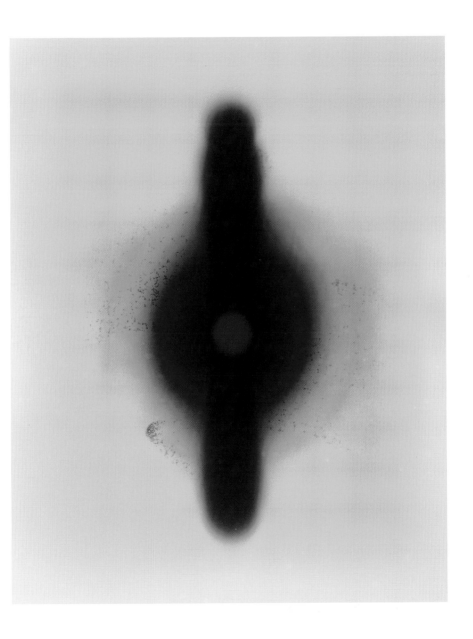

[221]
M E R R Y A L P E R N
Window Series, #9
1994
Gelatin Silver Print
20 x 16 inches (50,8 x 40,6 cm)

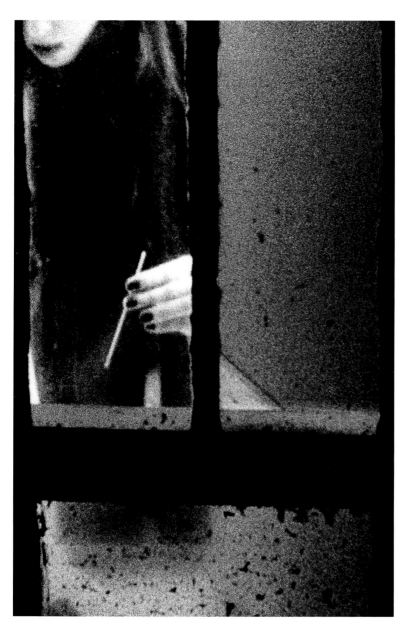

A N D R E W B U S H
Man traveling southeast on the 101 freeway at approximately 71 mph
somewhere around Camarillo, California on a summer evening in 1995
1995
Chromogenic Print
30 x 40 inches (76,2 x 101,6 cm)

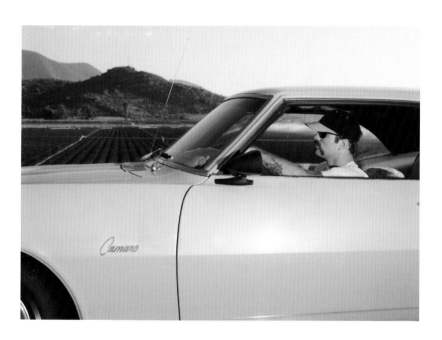

[223]
G A R Y S C H N E I D E R
Robert
1996
Toned Gelatin Silver Print
36 x 29 inches (91,4 x 73,7 cm)

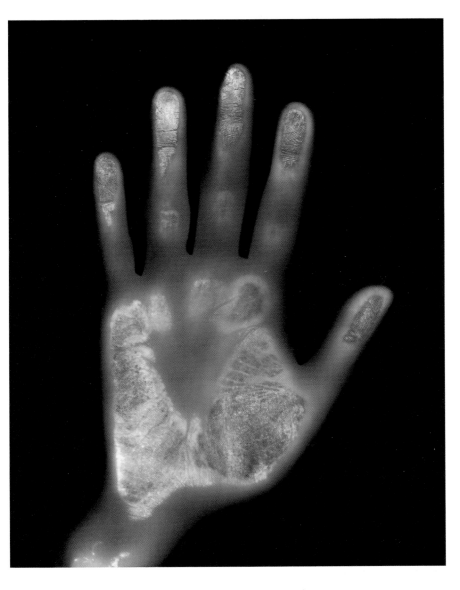

[224]
R I C H A R D M I S R A C H
Fool's Pond, 9:50 p.m.
June 30, 1996
Chromogenic Dye Coupler Print
48 x 60 inches (121,9 x 152,4 cm)

[225]
N I C H O L A S N I X O N
The Brown Sisters
1996
Vintage Gelatin Silver Print
8 x 10 inches (20,3 x 25,4 cm)

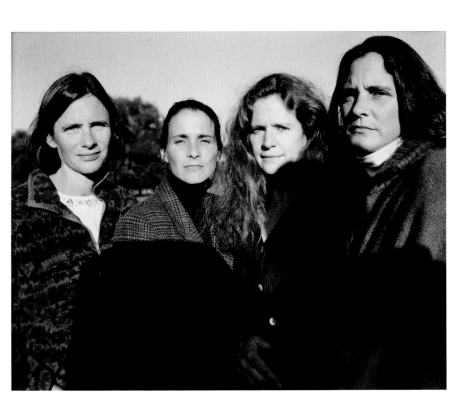

[226]
J A C K P I E R S O N
Untitled
1995
Chromogenic Print
30 x 40 inches (76,2 x 101,6 cm)

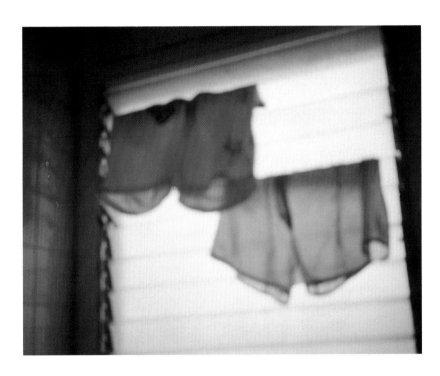

[227]
H I R O S H I S U G I M O T O
The Bass Strait and Table Cape
1997
Gelatin Silver Print
20 x 24 inches (50,8 x 61 cm)

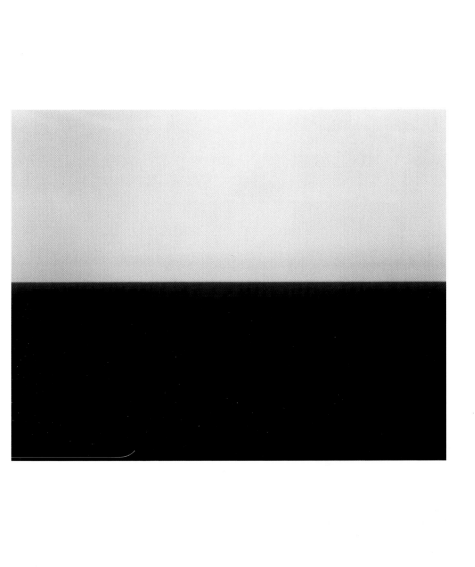

[228]
A N N I E L E I B O V I T Z
Lil' Kim, Rap Artist, New York City
1999
Iris Print
35 x 33 inches (88,9 x 83,8 cm)

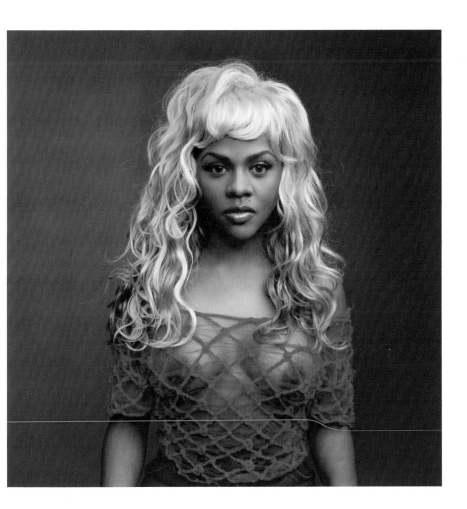

HOTO CREDITS

e from works in the public domain, nearly all images reproduced in this volume are copyrighted by their makers,
y the respective families, estates, foundations, or representatives of the artists. In addition, we would like to acknowl-
e the following galleries, institutions and individuals:

e 16: Courtesy Keith de Lellis Gallery, New York; plates 17, 33, 87 and 115: © Aperture Foundation Inc., Courtesy
Strand Archive; plate 26: Courtesy The Robert Miller Gallery, New York; plates 27, 54, 58, 64 and 74: © Arizona
rd of Regents, Center for Creative Photography; plates 29: Courtesy Joanna Steichen; plates 34, 45, 59, 63, 88: ©
ker Evans Archive, Courtesy The Metropolitan Museum of Art, New York; plates 51, 110, 120, 128, and 140:
tesy Howard Greenberg Gallery, New York; plates 67, 151, 174, 188 and 192: Courtesy Fraenkel Gallery, San
cisco; plate 77: Courtesy Jane Corkin Gallery, Toronto; plates 86, 91, 99 and 108: © The Estate of Harry Callahan,
tesy PaceWildensteinMacGill, New York; plates 95, 213 and 221: Courtesy Bonni Benrubi Gallery, New York; plate
© Condé Nast Publications, Inc., Courtesy American Vogue; plates 106, 165 and 170: Courtesy Stephen Daiter
ery, Chicago; plates 122, 149, 158, 160, 193, 202 and 215: Courtesy Edwynn Houk Gallery, New York; plates 126
59: Courtesy Dennis Stock; planches 135, 153, 167 and 197: Courtesy Laurence Miller Gallery, New York; plate
copyright © Estate of Diane Arbus, Courtesy Jan Kensner Gallery, Los Angeles; plate 146: © Charles Moore,
tesy Black Star; plates 162, 210, 212 and 226: Courtesy Cheim & Read Gallery, New York; plates 163, 166, 181,
187, 200 and 208: Courtesy PaceWildensteinMacGill, New York; plate 175: © Susan Meiselas/Magnum, Courtesy
an Meiselas/Magnum; plates 177 and 199: © The Estate of Robert Mapplethorpe, Courtesy The Robert
plethorpe Foundation; plate 178: © Pro Arts, Inc.; plates 180 and 225: Courtesy Zabriskie Gallery, New York; plate
Courtesy Metro Pictures, New York; plates 190 and 201: Courtesy Janet Borden Gallery, New York; plates 194,
and 222: Courtesy Julie Saul Gallery, New York; plate 196: Courtesy Leo Castelli Gallery, New York; plate 203:
tesy Paula Cooper Gallery, New York; planche 205: Courtesy Fahey/Klein Gallery, Los Angeles; plate 207: © Estate
avid Wojnarowicz, Courtesy P.P.O.W., New York; plates 209 and 227: Courtesy Sonnabend Gallery, New York; plate
Courtesy Luhring Augustine Gallery, New York; plate 218: Courtesy Matthew Marks Gallery, New York; plate 223:
tesy P.P.O.W., New York; plate 224: Courtesy Robert Mann Gallery, New York.

k cover photo: Robert Mapplethorpe, *American Flag,* 1977. © The Estate of Robert Mapplethorpe.

KNOWLEDGMENTS

dition, I would like to express my gratitude to the multitude of colleagues and friends who provided additional advice
assistance. Who's Who of photography : Eleanor Barefoot, Janet Borden, Frish Brandt, Jane Corkin, Warren
le, Keith Davis, Jamie Dearing, Sherry Turner De Carava, Susan Ehrens, John Erdman, Jed Fielding, Kaspar
chmann, Barry Friedman, Tom Gitterman, Edwynn Houk, Charles Isaacs, Alan Klotz, Kim Jones, Stephen
ansky, Scott Nichols, Howard Read, Adam Reich, Janet Russek, Julie Saul, David Scheinbaum, Gary Schneider,
Singer, Andrew Smith, Joel Soroka, Norma Stevens, Anna Winand and Helene Winer.

y, a special thanks to my gallery staff – Project coordinators: Jennifer Brushaber and Kate Palmer ; Project associ-
: Christina Bingel, Dan Cooney, Rachel Parker and Blair Rainey; and Associate Director: Ariel Meyerowitz.

© 2005 ASSOULINE PUBLISHING for the present edition
601 West 26th Street, New York, NY 10010.
Tel. 212-989-6810, fax: 212-647-0005
www.assouline.com

ISBN: 284323 699 1
Color separation : Gravor (Switzerland).
Printed and bound by Grafiche Milani (Italy).